# Greek and Roman Sculpture in Gold and Silver

*Second in a series of
monographs on famous sculptors
or unusual sculpture.*

## Cornelius Vermeule

*Museum of Fine Arts, Boston*

Copyright 1974
Museum of Fine Arts, Boston
Library of Congress
Catalog card no. 74–80074
ISBN 0-87846-081-0
Designed by Barbara Hawley

**Acknowledgments**

In preparing this study I have had the help of my colleagues in the Department of Classical Art, Museum of Fine Arts, Boston, chiefly of the Associate Curator and Keeper of Coins, Mary B. Comstock. I should also like to thank Herbert A. Cahn, Anthony Clark, Christiane Dunant, Jerome M. Eisenberg, Dorothy K. Hill, Hans Jucker, Mathias Komor, David G. Mitten, Andrew Oliver, Jr., and the late Donald Strong for their assistance. The authorities of the various museums and the private collectors involved have kindly permitted study and, in appropriate instances, authorized illustration of the works of art in their care. A gift from Dr. and Mrs. Ernest Kahn has helped make this publication possible.

# Greek and Roman Sculpture in Gold and Silver

The important subject of classical sculpture in the precious metals has not been treated to any extent in modern literature. When this form of art has been discussed, it has been considered casually or, at best, as an adjunct to monographs on or catalogues of gold and silver plate or tableware, notably in the *Catalogue of the Silver Plate (Greek, Etruscan and Roman) in the British Museum,* published in 1921. Since the ancients prized this art highly, a modern review of the evidence seems desirable.

The surviving body of material is, naturally, more related to or dependent on hidden hoards than is the case for bronzes or marbles. In Roman Gaul of the second to third centuries of the Christian Era, these hoards can be dated by finds of coins that have accompanied them. Groups of small statues in gold and silver seem to have come from temple treasuries or the household shrines of wealthy villa owners. Sets of the gods and goddesses representing the days of the week were popular in the second instance.

The ancient literary testimonia are ample, usually for larger cult and commemorative figures, especially portraits of Hellenistic rulers and Roman emperors or famous members of their families. The stories of the golden Tyche-Fortuna passed from dying emperor to his successor bring these statuettes into the realms of crown jewels, like the contents of the Mediaeval church treasuries, which took over the imperial possessions as well as those of the pagan temples. The bulk of what actually survives reflects the mass productions of Roman imperial economy — the routine personal cult of a pan-Mediterranean material civilization, together with several military portraits fashioned for the Roman legions and decorative "table" objects. Although there are literary references to life-sized statues in gold or silver, as opposed to the chryselephantine images, none of these survive even in fragments.

A surprising number of gold and silver statuettes can be dated on stylistic grounds to the period A.D. 200–400. This is chiefly because most ideal or divine subjects take on datable, portrait-like facial features. In Late Antiquity perhaps more such sculptures were buried in haste and therefore survive, but the art seems to parallel that of quasi-imperial commemorative dishes from the imperial workshops of Constantinople or Antioch and elsewhere.

Both the ancient Near East and Egypt had a tradition of this art, the production of complex statues and statuettes in gold and silver. The Near Eastern tradition could have influenced the arts in Orientalizing through Archaic to classical Greece, but it scarcely seems to have made any surviving mark in the Greek world, despite the close contacts between Ionia and the Near East or despite the booty captured from the armies of the Achaemenian Great King in successive wars. The Egyptian tradition, the "amulet" art of the New Kingdom to the Saite and Ptolemaic periods, clearly forms the basis of gold and silver sculpture in the classical world from 400 B.C. into the second century A.D. If any classical art can be termed "Alexandrian," it is certainly the manufacture of statuary of small size in gold and silver. The narrow-minded rigidity of a declining Egypt was passed on as an obvious, unfortunate legacy to the craftsmen of the Roman imperial world in both East and West.

The types of figures can be divided, roughly and chronologically, into those of the fourth century B.C., of the Hellenistic age, of its general successor the Graeco-Roman world, and, finally, of the Roman imperial period. This last category comprises the statuettes or busts representing Roman emperors or members of their families, paralleling the ancient literary testimonia already mentioned.

The few gold and silver statuettes or group compositions of the fourth century B.C. are like the divinities and lesser mythological figures of contemporary statues in bronze or marble and marble architectural friezes. These can range from a Zeus of the Pheidian age humanized in gold in the fourth century to a passage from the mausoleum frieze rendered freely into gold to form the upper part of a comb.

Hellenistic sculptors pioneered subjects in gold and silver as they did with other media. Infants of divine aspect (Herakles or Dionysos) or merely genre babies became fashionable. Dancers and reveling divinities take their places alongside seated Hermeses or nude

Aphrodites. Animals are found more frequently, as they are in marble or bronze. The preciousness of the Hellenistic rococo rather than the grandeur of the Pergamene baroque sets the tone for sculpture in the precious metals during the Hellenistic period. The art emerged at this time as one for the newly powerful semibarbarian prince or the newly rich merchant in some vast urban center such as Egyptian Alexandria or Syrian Antioch.

The patently Graeco-Roman statuettes center around the groups of divinities already mentioned as having formed the enrichments of family shrines. Hermes, or Mercury, the god of commerce clutching his purse, is one of the most popular images, either alone or in the sets that can be related to subjects such as the days of the week. Tyche, or Fortuna, based on the famous imperial image handed from emperor to emperor, appears in both metals and various sizes or degrees of complexity. The Graeco-Egyptian divinities are popular, particularly Harpokrates. Regional gods and goddesses, like the "sources" or fountain nymphs of Roman Gaul, have survived in these metals, often executed in bizarre styles and novel details of technique.

The purely Roman imperial sculptures have been described as votive busts in gold and as statuettes in both metals of the emperors. Those that survive belong to the reigns of Marcus Aurelius and Septimius Severus, that is, roughly 170 to 210. Their places of discovery, where known, confirm that they were made to be exhibited to the troops or carried in the portable chapels of the legions. A small group of Graeco-Roman statuettes of the gods, notably Hermes or Mercury, appear to have the features of Augustus or Tiberius.

The conclusions of a general survey reaffirm that the art of classical statuary in precious metals is generally commercial and practically utilitarian, not nearly as aesthetically moving as Greek jewelry of the fourth century B.C. and the early Hellenistic period. What does survive from the fourth century B.C. is, like the Nike-Psyche earring in gold from the Tyszkiewicz collection, of exceptional quality and monumentality in miniature. Most of what has come down to us from so-called Hellenistic art seem to be copies of lost originals made in Graeco-Roman times. Quality is often lacking. Indeed, this is true throughout the Graeco-Roman period. The Late Antique statuettes, on the other hand, do include creations of unusual subject (minor divinity, seated goddess) and of prime quality.

# The Lists of Survivors

The lists could begin with ancient Near Eastern and Egyptian examples, because they give a good measure of what was available to craftsmen in the Greek and Roman worlds. Since many of the Egyptian pieces are contemporary with the Hellenistic and Graeco-Roman statuettes, the connections are closer than might appear at first glance. These lists of Greek, Hellenistic, Graeco-Roman, and Roman imperial examples are a sampling and do not claim to be an exhaustive *corpus*.

Any discussion of ancient sculpture in gold and silver must fix certain limitations and include its own definitions. This is not a restudy of jewelry; it is primarily a survey of freestanding statuary on all scales. An earring may terminate in a wonderfully wrought winged Eros flying through the air with wreaths in hand. The Eros is a piece of sculpture secondary to his relationship as a hanging from an ear, real or as part of a statue or as a votive in a tomb. Another Eros represented as standing on a column would be included here because the artist's creative approach is as an independent work of art rather than as an ornament. If the column leads to a long pin, then the problem of scope within this survey is more complicated.

When a statuette in gold or silver has a loop on the top of its head, and is therefore technically classed with the amulets, it is most difficult to determine whether it should be included in these lists. The statuary qualities of the figure often mark the decision to record alongside fully freestanding statuettes. In late Egyptian sculpture nearly all statuettes have loops and therefore are amulets. Any study of the subject must consider a number of them. In what follows, their relationships to the Graeco-Roman world have been stressed.

# Literary Evidence

**1200 B.C. or later**
Gold and silver dogs by Hephaistos, guarding the palace of Alkinoös in Phaiakia. *Odyssey* VII, 81 ff.

**550 B.C.**
Gifts of King Croesus at Delphi: "lion in pure gold, having a weight of ten talents; . . . gold statue of a woman three cubits high." Herodotus I, 50–52. Gifts at Ephesos: the golden bulls. Herodotus I, 92.

**350 B.C.**
Gold statue of Phryne, Praxiteles' mistress, set up at Delphi on a column of Pentelic marble. Athenaeus XIII, 591 B.

**340 B.C. and A.D. 65.**
Nero gilds a bronze portrait of Alexander as a boy; the gold is later removed, when this display of bad taste was felt to have destroyed the statue(?)'s artistic value. Pliny, *Natural History* XXXIV, 63.

**216 B.C.**
"Golden statue of Victoria weighing 220 pounds presented by the Syracusans to the Roman Senate." Livy XXII, 37, 2–5.

**63 B.C.**
A large gold statue of Mithridates, six feet high, in the triumph of L. Lucullus. Plutarch, *Life of Lucullus* 37.

**61 B.C.**
In the Asiatic triumph of Pompey, "the opinion that the use of silver was first transferred to sculpture for making statues of the divine Augustus, as a result of the flattery characteristic of those times, is false. For in the triumphal procession of Pompey the Great we find that a silver statue of Pharnaces I [c. 185–169 B.C.], king of Pontus, was carried, and likewise one of Mithridates *Eupatōr*, and also some gold and silver chariots." Pliny, *NH* XXXIII, 151. [Also carried]: "golden moon weighing thirty pounds, . . . three golden statues representing Minerva, Mars, and Apollo, . . . a square golden mountain, on which stood stags, lions, and fruit trees of all kinds and which was entwined with a golden vine." Pliny, *NH* XXXVII, 12–14. "A gold portrait statue [of Mithridates Eupator?] measuring eight cubits from the base." Appian, *Mithridatic War* XVII, 116–117.

**The Later Republic, the Gracchi to Cicero.**

"Not only are men mad for silver in great quantity, but they are perhaps even madder for it in the form of works of art, and this has been true for so long a time now that we today pardon ourselves. Gaius Gracchus had some figures of dolphins which he bought for the price of five thousand sesterces per pound." Pliny, *NH* XXXIII, 147.

**Sulla, circa 80 B.C.**
On the Capitoline, "a gold figure of Jugurtha being handed over for justice by Sulla himself." Plutarch, *Life of Sulla* 6. Presumably these "gold" public statues really are gold rather than just gilded bronze. The recently regilded standing and equestrian statues or groups in front of the Philadelphia Museum of Art and at the entrances to the bridges across the Potomac in Washington show how effective, how like solid gold good gilding can be.

**Octavian, circa 30 B.C.**
"A gold statue, representing him dressed as he was when he entered the city, was set up on a column in the Forum, with prows of the [captured] ships placed all around the column." Appian, *Civil Wars* V, 130.

About this time, or earlier, a golden statue of Cleopatra was placed in the temple of Venus. Dio Cassius LI, 22, 1–3.

# The Roman Empire

### Augustus (27 B.C.–A.D. 14).
"When the Senate and the people once again contributed silver for statues of him [Augustus], he set up a statue not of himself but rather of *Salus Publica* [the Health of the State] and also to *Concordia* and *Pax*." Dio Cassius LIV, 35, 2. These images may be copied in miniature in one or more of the surviving silver statuettes of goddess-personifications. "In fact, he even melted down silver statues which had once been set up in his honor, and with the total proceeds from these he dedicated gold cauldrons to Apollo on the Palatine." Suetonius, *The Divine Augustus* LII.

### Tiberius (A.D. 14–37).
The temple of Augustus: "they placed a golden portrait of him on a couch in the temple of Mars, and to this portrait they directed all the details of worship which they were later to apply to his cult image." Dio Cassius LVI, 46, 3–4. This portrait must have been a bust.

### Caligula (37–41).
"In this temple [to his own divinity] stood a golden portrait-statue [of Caligula], and it used to be dressed every day in the sort of clothing which he himself wore." Suetonius, *Gaius Caligula* XXI–XXII. About his sister Drusilla: "and that a golden statue of her should be set up in the *Curia*." Dio Cassius LIX, 11, 2–3.

### Claudius (41–54).
"At first he accepted only one portrait, and that merely of silver, and two statues, one of bronze and one of stone, which were voted to him." Dio Cassius LX, 5, 4–5.

### Nero (54–68).
Golden images of Minerva and Nero were set up in the *Curia* after the murder of Agrippina (and the exposure of the plot against his, Nero's life). Tacitus, *Annals* XIV, 12.

### Vespasianus (69–79).
Regarding the triumph of Titus and Vespasian following the sack of Jerusalem, "In the next section [after the Menorah, etc.] a good many images of Victory were paraded by. The workmanship of all of these was in ivory and gold." Josephus, *Jewish War* VII, 5, 132ff.

### Titus (79–81).
"He set up a golden statue in his [Britannicus'] honor on the Palatine; he also dedicated another statue, an equestrian figure in ivory." Suetonius, *The Divine Titus* II.

### Domitianus (81–96).
"He permitted no statues to be set up in his honor unless they were of gold and silver and were of a certified weight." Suetonius, *Domitian* XIII, 2.

### Hadrianus (117–138).
At the Argive Heraion: "The peacock dedicated by the Emperor Hadrian is of gold and of gleaming gems. He made the offering because this bird is supposed to be sacred to Hera." Pausanias II, xvii, 6.

### Antoninus Pius (138–161)?.
Herodes Atticus dedicated gold and ivory figures in the Temple of Poseidon at Isthmia, including at least two gold Tritons, the parts below their waists being of ivory. Pausanias II, i, 7–8.

### Marcus Aurelius (161–180).
The Senate voted in A.D. 176 to set up silver portrait statues in honor of Marcus Aurelius and Faustina in the Temple of Venus and Rome. "It also decreed that a golden portrait statue of Faustina should always be carried into the theater on a chair on every occasion when the emperor was to be a spectator." Dio Cassius LXXI, 31, 1.

### Septimius Severus (193–211).
At the funeral ceremony in memory of Pertinax, "He also decreed that a gold portrait statue should be brought into the Circus on a chariot drawn by elephants." Dio Cassius LXXIV, 4, 1ff. Septimius Severus wanted the golden statue of Fortuna, which Antoninus Pius had kept in his bedroom and passed on to Marcus Aurelius, copied so that his sons Caracalla and Geta could each have one. *Historia Augusta,* Severus, XXIII, 5–6; see also Antoninus Pius, XII, 5; Marcus Antoninus, VII, 4.

### Claudius II (268–270).
"To him also, and this was an honor granted to none previously, the Roman populace set up a gold statue, ten feet high, in front of the temple of

Jupiter *Optimus Maximus*. Again in his honor, with the assent of the entire world, a silver statue of him in the *tunica palmata*, weighing 1,500 pounds, was set up on a column." *Historia Augusta,* The Divine Claudius III, 2–7.

**Aurelianus** (270–275).
"[Firmus, a small pretender and ally of Zenobia] possessed two elephant tusks, each ten feet long, from which Aurelian intended to make a throne by adding two other tusks; on this throne there would sit a gold statue of Jupiter, studded with gems and wearing a sort of *toga praetexta*, which would be set up in the temple of the Sun." *Historia Augusta,* Firmus, etc., III, 4.

**References**
Quotations used directly or indirectly in this section have been taken from J. J. Pollitt, *The Art of Greece 1400–31 B.C.,* 1965, and *The Art of Rome, c. 753 B.C.–337 A.D.,* Englewood Cliffs, N.J., 1966, both published by Prentice-Hall in the Sources and Documents in the History of Art Series, ed. H. W. Janson. Reference should be made also to the important article by Thomas Pekáry, "Goldene Statuen der Kaiserzeit," *Mitteilungen des deutschen archäologischen Instituts, Römische Abteilung* 75 (1968), 142–148.

## Conclusions

The most impressive sculptures before the imperial period were statues of sacred, votive animals, of impressive or bizarre women, and of backwoods, Orientalized Hellenistic rulers. The Hellenistic age seems to have produced some unusual specimens of the metalworkers' art, the golden moon, the gold and silver chariots (which could have been earlier, Near Eastern), and the square golden mountain, with its animals and fruit trees or vines, seeming like a large version of the bronzes of Mount Argaeus in Cappadocia. The imperial centuries were taken up with statues of the emperors, either those ordered by madmen such as Caligula and Nero or those set up by the emperor and Senate in honor of departed worthies (such as Faustina, wife of Marcus Aurelius, or the short-lived Pertinax).

One has the suspicion that more than a few of the so-called golden statues of rulers or gods set up in open, public areas were really creations in bronze, heavily gilded. This must have been true in the time of Claudius II Gothicus (268–270) and Aurelianus (270–275), when costly wars and barbarian depredations had all but driven the gold and silver coinage out of circulation. The related works of art in the precious metals had all gone underground, into the melting pot, or into the destructive hands of domestic and barbarian plunderers. Since nearly all the references to monuments in Roman times are to public monuments, it is not surprising that these references become fewer even during the material *renovatio* of the Tetrarch and Constantinian periods. Emperors and magistrates may have been ordering gold and silver statuettes for their table tops, but they were not commissioning such lifesized (or thereabouts) statuary for shrines and civic areas. Much artistry was beginning to go into the large, fancy silver and gold plates that were really pictorial compositions in high, three-dimensional relief.

# Contents of the Catalogue

# Greek

**1**

**Early Archaic (East Greek) goddess (Artemis?) or a votary in gold** from Ephesos. Ca. 600 B.C. H. 0.03 m. London, British Museum. F. H. Marshall, *Catalogue of the Jewellery, Greek, Etruscan, and Roman, in the Departments of Antiquities, British Museum,* London, 1911, p. 80, no. 1040, pl. X (hereafter cited as Marshall, British Museum *Jewellery*); D. G. Hogarth, *Excavations at Ephesus,* London, 1908, pl. IV, 4. She is comparable in style to the East Greek ivories. The hawks (B.M. nos. 1041 to 1044) are based on their Egyptian counterparts; they range in height from 0.017 m. to 0.01 m. These small-scale Archaic Greek figures bridge the tradition of Egyptian amulets and classical Greek statuettes in gold and silver. The majority of the Ephesos statuettes are actually fashioned in electrum; see P. Jacobsthal, *Journal of Hellenic Studies* 71 (1951), 90.

**2**

**East Greek, Achaemenian-style silver stamp seal,** or seal-shaped ornament in the form of a recumbent mountain sheep(?) Circa 540–525 B.C. H.(max.): 0.035 m. L.(max.): 0.033 m. Boston, Museum of Fine Arts, 1972.72. The surfaces have a dark, almost-black patina. Hollow cast, with the foot attached separately, this animal with his feet tucked under him is finished by chasing and stippling. An engraved (intaglio) stone was probably set in the bottom, within the oval border of granula-

tions. Said to have been found with other examples of metalwork and metalworking equipment, in a tomb in the Hermos Valley, this small figure provides a link between East Greek sculpture in the precious metals and the world of Achaemenian Persia or earlier Mesopotamia and Asia Minor.

**3**

**Silver statuette of a ram.** "The animal is made of sheet silver. Height: 1-7/32 in. Lent by [the late] Maxime Velay. Greco-Persian, fourth century B.C.": D. von Bothmer, in *Ancient Art from New York Private Collections,* New York, 1961, p. 71, no. 280, pl. 102. This animal also has his feet curled up under him. He does have pronounced ovine ears. The stippling of the hide is identical with that of the Boston animal, suggesting a similar date and perhaps even the same workshop for the two little sculptures. So far as can be told from the photograph, the Velay ram does not have a circular base for the insetting of a seal. Dietrich von Bothmer has kindly written (9 November 1972) that he too favors a sixth century B.C. date for the animal from Maxime Velay's collection.

**4**

**Archaic Greek gilded silver statuette of a warrior,** excavated on Chios. H. 0.065 m. K. Kourouniotes, *Archaiologikon deltion* 2 (1916), 208f., fig. 28, three views; whence S. Reinach, *Répertoire de la statuaire grecque et romaine,* vol. I. Paris, 1897, p. 263, no. 4 (hereafter referred

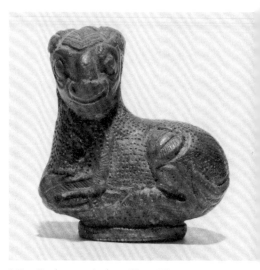

2. East Greek mountain sheep. Silver, 540 to 525 B.C. *Boston, Museum of Fine Arts. Otis Norcross Fund. 1972.72.*

to as Reinach, *Rép. stat.*). The *kouros* in helmet, cuirass, and tunic dates around 525 B.C. and has been compared with the Apollo Piombino. G. M. A. Richter has noted (*Kouroi,* London, 1960, p. 9): "No Greek kouroi of gold, silver, or amber seem to be known." (There is said to be one Italic example in amber.)

**5**

**Group of (three) hammered gold "Korai,"** Etruscan-Ionian, circa 500 B.C. or later. H. 0.043 m., 0.043 m., 0.05 m. Paris, Musée du Louvre (two), and Rome, Museo di Villa Giulia, the first two from Vulci or Caere (Campana), the last from Caere. G. Becatti, *Oreficerie antiche dalle minoiche alle barbariche,* Rome, 1955, p. 182, nos. 283, 284, 285, pl. LXXIII. The figures wear crowns and necklaces inlaid with semiprecious stones; they stand in the conventional Kore pose. The character of the little molded plinth or base under the largest of these three statuettes suggests they were created for votive as well as ornamental purposes. They are crude in some ways, elegant in others, and were surely made in Etruria, since much of their charm lies in their Etruscan "freshness" of concept. The Athena "Promachos" listed at the end of this catalogue is a modern forgery roughly in the intended circle of these figurines.

**6**

**Votive statue of a sow in gold,** dated in the fifth to fourth centuries B.C.

H. 0.0229 m., L. 0.0359 m. Hamburg, Museum für Kunst und Gewerbe, 1922.122. H. Hoffmann, V. von Claer, *Antiker Gold- und Silberschmuck,* Mainz am Rhein, 1968, pp. 190–191, no. 129. The sow was made in two halves with feet and tail attached; the date is reached by comparison with votive terracottas, particularly those from Boeotia.

**7**

**Zeus in gold.** The chief Olympian stands with his thunderbolt poised in the raised right hand, his eagle facing him on the extended left. He walks on a rectangular plinth that has a hole between the two sets of toes and remains of a rivet at the right rear. H. 0.044 m. The Minneapolis Institute of Arts, 70.32. C. Vermeule, *The Burlington Magazine* 112 (1970), 821, note 10. The type of this and the following statuette is that of the middle of the fifth century B.C. The date would seem to be no later than about 340 B.C.

**8**

**Zeus in gold,** as preceding, with the left leg drawn back to a slightly greater degree. H. 0.046 m. Boston, Museum of Fine Arts, 69.1222. Vermeule, *The Burlington Magazine* 112 (1970), 821f., figs. 46, 48. These statuettes with their severe, majestic heads were based ultimately on a famous image of Zeus or a heroic ruler that was created in the circle of Myron about 450 B.C. and that survives in a Roman marble copy in Munich; see A. Furtwängler, *Master-*

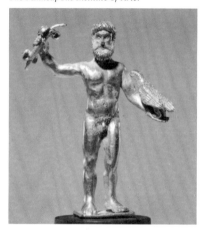

7. Zeus. Gold, presumably 340 B.C. *The Minneapolis Institute of Arts.*

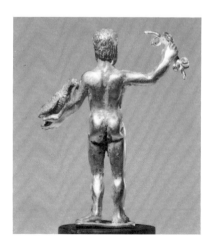

3

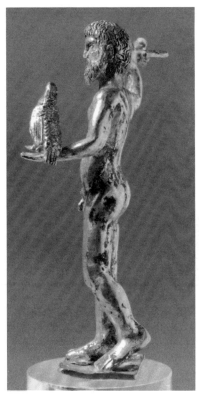

8. Zeus. Gold, presumably 340 B.C.
*Boston, Museum of Fine Arts. Helen and
Alice Colburn Fund. 69.1222.*

*pieces of Greek Sculpture,* edited by
Al. N. Oikonomides, Chicago, 1964,
pp. 215–217, figs. 90, 91.

**9**

**Group of gold statuettes.** Closely
allied with the two statuettes of Zeus
is a "Dodekatheon" of golden statu-
ettes varying in height from 0.042 m.
to 0.050 m. and in weight from 342
grains to 747 grains. (There is no
direct correlation between size and
weight.) These statuettes were re-
corded and photographed, in color,
in the collection of a Greek numis-
matist, Mr. Michael M. Marx, of
Chicago. Their diverse styles within
an overall, related framework sug-
gest they were made at the same time,
in a period at least 350 years after the
dates implied for the statuettes in
Minneapolis and Boston.

A. Achilles or Ares, a shield with a
snake coiled on it in the left hand.
H. 0.044 m. Weight 440 grains.

B. Apollo holding his lyre, based on
the Graeco-Roman Hermes types.
H. 0.045 m. Weight 396 grains.

C. Ares, spear in his right hand, an
object like a small bird in the left.
H. (to the top of helmet) 0.050 m.
Weight 432 grains.

D. Hephaistos holds up his hammer.
His head is of the fifth century B.C.
and there is an extra loop to the
himation. H. 0.044 m. W. 480 grains.

E. Poseidon appears with his trident,
which is large and held at an odd
angle. H. 0.043 m. W. 342 grains.

F. Zeus, holding eagle and thunder-
bolt, is in every respect similar to the
statuette in Boston. H. 0.046 m.
W. 375 grains.

G. Artemis holds a bow and arrow,
her chiton being articulated some-
what like the drapery of the Parthe-
non Fates. H. 0.042 m. W. 545 grains.

H. Hera has her hair adorned with a
diadem; her veil is hanging down her
back; she wears her small himation
like a mantilla over the shoulders.
H. 0.043 m. W. 637 grains.

I. Demeter holds a torch in her right
hand, "while searching for her daugh-
ter Persephone"; she has the draped
presence of a Neo-Attic Caryatid,
suggesting the earliest possible date
for the group. H. 0.044 m. W. 508
grains.

J. Aphrodite stands with her cloak
about the lower part of her body,
"disrobing to prepare for a bath,"
her "zig-zag" drapery being held in
an unusual fashion. H. 0.045 m.
W. 503 grains.

K. Athena, wearing a simple, sleeve-
less chiton, holds her shield with
Gorgon head in the left hand and her
spear in the right, the latter attribute
now missing. H. 0.047 m. W. 747
grains.

L. A goddess or personification,
identified by the owner as Euthenia,
cornucopia in her right hand, the
left in a balancing, tripping gesture.
H. 0.045 m. W. 457 grains.

The statuettes of Zeus in Min-
neapolis and Boston have passed

every stylistic and scientific scrutiny practised by the leading scholars of such matters in Europe and America. The presence of a third, extremely similar Zeus in the Chicago "Dodekatheon" does not inspire confidence in this statuette, or, indeed, in the two previously discussed and published. The Chicago Zeus has a head like the Chicago Hephaistos and the Chicago Poseidon, which are somewhat difficult to accept, without reserve, as antique and which, in turn, relate to several of the more bizarre male and female divinities of the group. A tentative conclusion might be that someone found two, or possibly three, votive statuettes of Zeus in a tomb or sanctuary, with perhaps others among the divinities, and then the finder or another party enriched the group by having a set of statuettes made in what proved to be a diversity of ancient and pseudoantique styles.

## 10

**Standing, youthful Herakles,** silver, in the Archaic style and dated fifth century B.C. H. 0.125 m. Paris, Musée du Louvre, from Paestum. A. De Ridder, *Catalogue sommaire des bijoux antiques,* Paris, 1924, p. 206, no. 2085, pl. XXVIII. He held a club or an arrow in his raised right hand and a bow and two arrows in the left. Style and proportions parallel the gold Zeus in Boston and its counterpart in Minneapolis.

## 11

**Gold comb,** ornamented with a group of Scyths in combat, one on horse-back and two on foot; a dead horse belonging to one of the latter lies beneath the mounted warrior. From the Solokha barrow, 21 km. south of Nikopol. H. 0.123 m. W. 0.102 m. Leningrad, Hermitage Museum. M. I. Artamonov, *Treasures from Scythian Tombs in the Hermitage Museum, Leningrad,* London, 1969, pls. 147, 148. The date would seem to be at the beginning of the fourth century B.C. (pp. 56f.). Since the group on top is shown in the round, this can count as "freestanding" sculpture.

## 12

**Gold pin,** from a Macedonian atelier of the third century B.C., surmounted by a group of Aphrodite and Eros. The figures and their supporting pillars are sculptured elements set on a bejeweled Corinthian capital. H. 0.04 m. Athens, National Museum. Stathatos Collection. From Thessaly: P. Amandry, *Collection Hélène Stathatos, Les bijoux antiques,* Strasbourg, 1953, p. 107, pl. XLI, no. 241. There are at least five other such hairpins in gold or silver, surmounted with figures of Aphrodite or of Eros. A notable example, Hamburg, 1929.18, in silver once gilded, shows Aphrodite Anadyomene standing on a Corinthian capital, Eros on her shoulder: H. Hoffmann, *Kunst des Altertums in Hamburg,* photos F. Hewicker, Mainz, 1961, p. 30, pls. 98A–99, p. 43, dated third to second century B.C.

# Hellenistic

**13**

**Gilded silver Sarapis.** H. 0.03 m. London, British Museum, from Paramythia in Epiros, found with the Payne Knight bronzes in 1792. H. B. Walters, *Catalogue of the Silver Plate (Greek, Etruscan and Roman) in the British Museum,* London, 1921, p. 3, no. 6, fig. 3 (hereafter referred to as Walters, British Museum *Silver Plate*). The god stands on a small plinth, holding out a *patera* in the right hand and cornucopia in the left. He wears the *kalathos,* long chiton, and himation over the left shoulder. There is a fillet around the hair; it is tied at the neck and hangs in a loop. The character and details of the bronzes in the Paramythia find would indicate an unusually early, Hellenistic date for this statuette. See H. B. Walters, *Catalogue of the Bronzes Greek, Roman, and Etruscan in the Department of Greek and Roman Antiquities, British Museum,* London, 1899, pp. 36 – 38, p. xiv; A. Michaelis, *Ancient Marbles in Great Britain,* Cambridge, 1882, pp. 119 – 121; W. Lamb, *Greek and Roman Bronzes,* London, 1929, pp. 171f., as in the fourth century to Hellenistic tradition and originally from Dodona. (But compare the silver "Megas Theos" from Asia Minor in Boston, which is clearly a Graeco-Roman product, a poor casting at that.)

**14**

**Silver boy and "fox-goose,"** found in 1844 near Alexandria, with coins of the early years of Ptolemy III (247 to 222 B.C.). H. 0.092 m. London, British Museum. Walters, British Museum *Silver Plate*, p. 3, no. 7, pl. VII. The boy sits with legs bent and feet crossed, turning his head away to his right from the bird that he holds in both hands; his face registers a painful laugh or a grimace, as the goose bites at his left ear. See also the silver statuette of a child holding a puppy, H. 0.10 m., from the Nicolaëvo treasure in Bulgaria: *Archäologischer Anzeiger* 1911, cols. 363-365, figs. 7, 8.

**15**

**Silver infant Dionysos,** seated on a molded base, right arm raised as if playing with an (unseen) animal, such as a panther; this motif is based on that of the infant Herakles strangling the snakes. There is a cloak around the left arm, and a large bunch of grapes seems to be concealed in this. The bottom of the base is perforated in an adjustable double layer, making it into a pepper shaker. The style, like the preceding, is "Alexandrian" Hellenistic, but the date of this particular piece is probably in the Roman imperial age, like the African servant *piperatorium,* to be considered next. H. 0.095 m. Boston, Museum of Fine Arts, 1972.863. New York art market, Collection of Mathias Komor. From Sidon. Serrure Collection: *Catalogues de ventes faites à Paris, le 6 décembre 1899* (pl. 8, 20) *et le 10 novembre 1900* (pl. 12, 364); Reinach, *Rép. stat.* III, p. 34, no. 7.

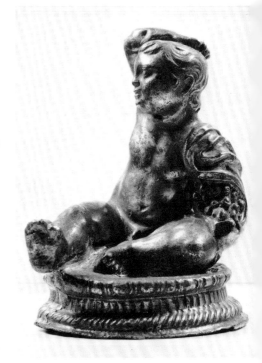

15. Infant Dionysos with grapes. Silver, Late Hellenistic. *Boston, Museum of Fine Arts. Helen and Alice Colburn Fund. 1972.863.*

**16**

**Silver "Ethiopian slave"** squatting, in the traditional attitude of the great urban bazaars of the Near East. Partially gilded. He is represented as asleep, wrapped in hood and mantle, and holding a lantern. There are six pouring holes in the hair above his forehead. H. 0.09 m. London, British Museum, from the Chaource (Aisne) treasure, generally dated on scattered numismatic evidence in the Antonine period or possibly slightly earlier. Walters, British Museum *Silver Plate,* pp. 38–39, no. 145, pl. XXIII, also (the treasure) pls. XXIII–XXX. F. M. Snowden, Jr., *Blacks in Antiquity,* Cambridge (Mass.), 1970, p. 82, fig. 57. Such Hellenistic genre objects were part of a Roman imperial table service or *ministerium,* but there is no reason one single part of this otherwise-homogeneous treasure could not have been older, especially as in this treasure it was the most important figural piece.

**17**

**Silver infant Dionysos,** holding a bunch of grapes; the surfaces are much corroded. H. 0.095 m. London, British Museum, from Cairo in 1874. Walters, British Museum *Silver Plate,* p. 12, no. 43, pl. VII. This second representation of the baby god of wine would seem, despite its poor condition, to stand stylistically and chronologically ahead of the two vessels for spices just discussed.

**18**

**Standing child in silver,** "la tête et le bras gauche levés, comme s'il tenait un papillon à un fil." A nude child holding an aryballos and a phiale, also in silver. *Collection Joseph de Rémusat,* Paris, Hôtel Drouot, 17–18 May 1900, p. 30, nos. 282, 285. No more details are forthcoming from the catalogue, but the subjects suit late Hellenistic "rococo" art.

**19**

**Galloping deer ("biche"),** silver, perhaps a figure from a Hellenistic group of hunters and animals. L. 0.117 m. Paris, Musée du Louvre, from "Beisân (Syria)." A. De Ridder, *Catalogue sommaire des bijoux antiques,* Paris, 1924, p. 207, no. 2100, pl. XXIX. Horns and three of the legs have been broken away. The animal was leaping forward and shying away suddenly, body elongated and head turned back toward the left shoulder. The workmanship is excellent, equal to the best such Hellenistic bronzes of animals in action.

**20**

**Large gold statuette of Ares-Mars,** represented as standing and nude, save for his crested helmet. He is a version of the central Italic or Roman Republican cult image of Mars Pater. The prototype is Hellenistic, going back to statues of Alexander the Great, and the date of this gold figure might be not long after 100 B.C., that is, in the last decades of the Roman Republic. H. 0.106 m. London, British Museum, from the Castellani col-

lection, 1872. Hollow, made in many separate elements and soldered together. Marshall, British Museum *Jewellery,* p. 360, no. 3013, pl. LXIX; Reinach, *Rép. stat.,* V, 1, p. 264, no. 4. "He . . . has his r. hand raised, probably for holding a spear now missing. His l. hand is lowered, and carries an oval shield with embossed cable border. The shield is attached to the wrist by a wire. The top and edge of the base are ornamented with a pattern of thunderbolts in relief." The work is somewhat crude and the legs a bit misshapen, perhaps owing to use (or misuse) in later antiquity and damage due to burial.

**21**

**Ares or "Mars Pater,"** silver, a well-known cult-image in Rome of the late Republic and early Empire. H. 0.55 m. Paris, Musée du Louvre. A. De Ridder, *Catalogue sommaire des bijoux antiques,* Paris, 1924, p. 206, no. 2092, pl. XXIX. The god wears an elaborate helmet and a cloth around his waist; he holds a trophy on his left arm and held a spear in his lowered right hand. This is a routine, votive example of a figure connected with the shrine on the Capitoline Hill where Augustus placed the standards returned by the Parthians in 19 B.C. The type, on an aureus dated A.D. 226, forms the centerpiece of a necklace with medallion pendants once in the Morgan collection. W. Dennison, *A Gold Treasure of the Late Roman Period,* New York 1918, p. 141, pls. XXVI, XXVII.

**22**

**Dancing maenad in silver,** cast partly solid and partly hollow. H. 0.20 m. *Antiquités Égyptiennes, Grecques et Romaines, Provenant de l'Ancienne Collection Borelli Bey,* Paris, 11–13 June 1913, pp. 46f., no. 405, pl. XXXVII; Reinach, *Rép. stat.,* V, 1, Paris, 1924, p. 202, no. 2, as a Nike. Termed "très beau travail alexandrin," this figure has a Canovesque (his Hebe) quality in its hair style and drapery, also in the dancing pose. The "Artemis" in silver in the British Museum from the Macon Treasure (Walters, *British Museum Silver Plate,* p. 9, no. 28, pl. VI; Reinach, *Rép. stat.,* V, 1, p. 138, no. 6) shows how the figure ought to appear if it were unquestionably antique. A bronze Nike from Flanders (Musée de Mariemont, *Les Antiquités Égyptiennes, Grecques, Etrusques, Romaines et Gallo-Romaines du Musée de Mariemont,* Brussels, 1952, p. 169, no. F 11, pl. 60) gives a good illustration of the prototype, or a good parallel.

**23**

**Silver Aphrodite with mirror.** H. 0.12 m. *Collection Borelli Bey,* p. 47, no. 406, pl. XXXVI; Reinach, *Rép. stat.,* V, 1, p. 152, no. 3, as bronze. This clumsy statuette has been termed "Epoque alexandrine, IIe siècle avant J.C." She is diademed, "chignon sur la nuque," and holds an uncertain object in the left hand. Like the previous, the figure raises suspicions, perhaps less so in this case; if ancient, this statuette ought to have been

made after 100 B.C. and before A.D. 300.

**24**

**Gilded silver left leg and foot** of a draped seated statuette, probably of Zeus. Boston, Museum of Fine Arts, 10.172. *Collection Joseph de Rémusat,* p. 30, no. 281, pl. XII. The himation is draped in large folds in the style of the fourth century B.C., but the date could equally well be later, in the period from 200 B.C. to the Julio-Claudian era. The quality is exceptional, hence the importance of the fragment: H. 0.078 m., as preserved.

24. Left leg and foot of a seated Zeus(?). Gilded silver, late Hellenistic. *Boston, Museum of Fine Arts. James Fund and Special Contribution.* 10.172.

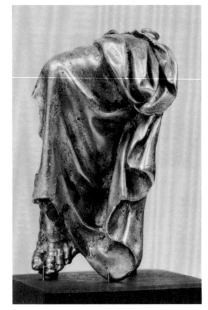

# Graeco-Roman

**25**

**Statuette of a philosopher,** silver, Paris, Bibliothèque Nationale, found at Bordeaux in 1813. H. 0.13 m. This is a Roman copy of a (lost) Hellenistic original and has been identified tentatively as a variation of the statue of Hermarchos, created about 270 B.C.: G. M. A. Richter, *The Portraits of the Greeks,* II, London, 1965, p. 205, fig. 1321, and older references. The figure is typically Roman in the details of the stool with animals' feet, the type of sandals, and the naturalistic qualities of the large *rotulus* from which the man of learning reads. The statuette's value as an iconographic document is minimal, but it makes an unusual document in the history of complete statues of the early Hellenistic philosophers.

**26**

**Statuette of a youth,** silver, Rome, Palazzo dei Conservatori. H. (without base) 0.232 m. The figure seems to be an Italic god in rustic Hellenistic form, and the features are more those of an Apollo in the fourth century B.C. tradition of Euphranor than, as suggested, a youthful, beardless Zeus ("a type not uncommon among Italian bronzes"): H. S. Stuart Jones, *The Sculptures of the Palazzo dei Conservatori,* Oxford, 1926, pp. 293f., no. 29, pl. 115. A date near the end of the Roman Republic seems very likely. The base does not belong. Part of the right upper arm and patches in the head have been restored. The lowered left hand held a phiale, and the raised right arm seems to hold part of a thunderbolt. The work has been termed not particularly fine, and the statue is much battered, especially in the lower part.

**27**

**Crouching panther,** silver, identified as Graeco-Persian of the second century B.C. H. 0.04m. Princeton (New Jersey), Princeton University, the Art Museum. Inv. no. 53 – 26. F. F. Jones, *Ancient Art in The Art Museum Princeton University,* Princeton, 1960, pp. 52-53; *idem, Archaeology* 7, 1954, p. 239. "The crouching panther . . . was one of a pair or a set that may have spanned part of the curved lid of a vessel. The use of animals for ornament and the stylized portrayal are old elements in Persian art. The stylization, however, has been limited to superficial de-

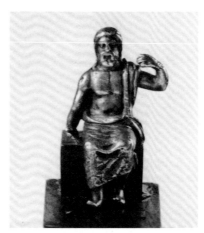

28. Zeus enthroned. Gilded silver, Graeco-Roman. *Boston, Museum of Fine Arts. Seth K. Sweetser Fund. 60.1449.*

tails and the modelling of the animal is more in keeping with the three-dimensional vigor of Hellenistic art." In all these respects, the animal falls near the end of a long sculptural tradition in Graeco-Persian art, before purely Greek and then Graeco-Roman features become the standards of identification in this form of decorative art. In several senses, this is a borderline piece for the catalogue, since it is part of a utensil or votive vessel and it has Near Eastern overtones. Its sculptural independence and its classical forms and details lead to its inclusion here.

**28**

**Silver gilded Zeus enthroned,** once holding a scepter-staff and a thunderbolt (?). Himation around the waist and over the left shoulder from the back. H. 0.045 m. Boston, Museum of Fine Arts, 60.1449. M. B. Comstock, *Bulletin of the Museum of Fine Arts, Boston* 59 (1961) 110, fig.; C. Vermeule, *Classical Journal* 58 (1962) 2f., fig. 2; *The Trojan War in Greek Art, A Picture Book,* M.F.A., Boston, 1963, fig. 15A. This statuette is one of the few copies of the gold and ivory Zeus at Olympia made by Pheidias; cf. G. Becatti, *Problemi fidiaci,* Milan, 1951, pls. 72f.

**29**

**Gilded silver seated Zeus-Jupiter,** with a head of the later fourth century or Hellenistic "Otricoli" type, a thunderbolt on his lap in his lowered right hand, and a scepter-staff once

in the raised left. His feet are placed on a stool, as befits a cult image. H. 0.072 m. London, British Museum. Walters, British Museum *Silver Plate,* pp. 10f., no. 35, pl. VI, evidently part of the Macon find. This statuette almost certainly reflects one of the major images related to the Capitoline Jupiter in Rome.

**30**

**Gilded silver seated Zeus,** the position of the arms reversed and no attributes visible. The features are cruder, less easy to relate to major sculpture and more like Gallo-Roman bronzes. The seat is flat, as is the support for the feet. H. 0.063 m. London, British Museum, from Castellani in 1872. Walters, British Museum *Silver Plate*, p. 11, no. 36, fig. 7.

**31**

**Silver bust of Zeus Sarapis,** a hole for the kalathos in the top of the head; set on a circular silver base. H. 0.159 m. New York, the Metropolitan Museum of Art, loaned by Mr. and Mrs. Jan Mitchell. Ex collections de Nanteuil and Joseph Durighello. *Cat. Vente Galerie Georges Petit,* Paris, 20 June 1925, no. 7, pl. IX; *Cat. Sotheby,* London, 13 June 1966, p. 55, lot 129, illustrated: "possibly from Alexandria," and there are good stylistic parallels in marble or bronze from imperial Egypt.

**32**

**Silver standing Zeus,** the head of the most canonical, fourth century B.C.
to Hellenistic (Otricoli) type. The god holds a lotus-tipped thunderbolt in the right hand and once had a scepter-staff in the left. His complex cloak hangs over the outstretched right arm and down the back from the left shoulder, the points of the folds being held down with weights. At his left side, as additional support, is a she-goat with open mouth. The base is modern. H. 0.065 m. London, British Museum. Walters, British Museum *Silver Plate*, p.8, no. 27, pl. VI, part of the Macon find. The type has many parallels in Graeco-Roman bronzes. Without the goat, or with an eagle in its place as support, the prototype can be identified from coins as a major cult image in Rome during the Empire. Like all the Macon statuettes, the craftsmanship is capable in a Roman imperial sense, but hardly brilliant in comparison with many Hellenistic and Graeco-Roman bronzes.

**33**

**Silver bust** "of the local 'Jupiter' was found, in 1924, in a crushed state, together with a coiled silver ribbon and a statuette of Hercules within the front of a small shrine, likewise of silver, at a Roman station on the Little St. Bernard"; described generally from ceramic finds in *Notizie degli Scavi di Antichità* 1924, 391. Aosta Museum, now restored. "A vigorous example of semi-barbaric rendering of a classical theme." A. W. van Buren, *American Journal of Archaeology* 41 (1937) 489–491, fig. 6. The date ought to be in the late
Antonine or Severan periods, the face of Jupiter being somewhat like the Marcus Aurelius from Avenches. (See below.)

**34**

**Anatolian Zeus "Dolichenos,"** silver, a provincial divinity seated on a humped bull. H. 0.045 m. Paris, Musée du Louvre, from the region of Smyrna. A. De Ridder, *Catalogue sommaire des bijoux antiques,* Paris, 1924, p. 207, no. 2094, pl. XXIX. The raised left hand probably held a scepter-staff; the lowered, extended right holds a phiale. A number of sites from Ionia to Pergamon to Ankara have produced images of or dedications to Zeus combined with bovines such as this.

**35**

**Silver, fragment from a standing statue, of Jupiter-Zeus,** in his manifestation as the Roman god of the woodlands and hunting, Silvanus. H. 0.035 m. Paris, Musée du Louvre. A. De Ridder, *Catalogue sommaire des bijoux antiques,* Paris, 1924, p. 207, no. 2096, pl. XXIX. The bearded head, in the tradition of cult-statues of Zeus in the fourth century B.C., and part of the neck are preserved. The hair is tied with a fillet and crowned with a wreath of pine cones. The quality of the casting and finishing (chasing) is excellent. The small statue was probably made in Italy or the Latin West in the Antonine period of the Roman Empire. Silvanus, standing in the pose of a Jupiter from the Capitoline and

Palatine temples in Rome, is well known from small marble statues, decorative reliefs, bronze statuettes, and the reverse of a Roman imperial bronze medallion struck in the reign of the Emperor Antoninus Pius (A.D. 138–161): compare F. Gnecchi, *I Medaglioni romani*, Milan, 1912, II, p. 19, no. 85, pl. 52, no. 8 (A.D. 156). This medallion shows him as a young, beardless god, but he also appears as the older divinity: see Reinach, *Rép. stat.*, IV, p. 29, no. 1 (a statue found in the Campania and recorded in Rome).

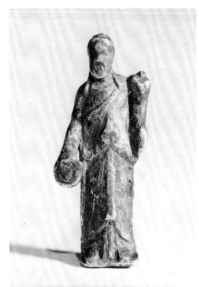

37. Phrygian Dionysos-Sabazios. Silver, Graeco-Roman. *Boston, Museum of Fine Arts. John Michael Rodocanachi Fund. 1971.142.*

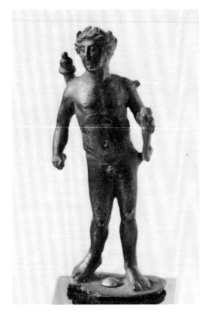

36. Apollo. Silver, Graeco-Roman. *Boston, Museum of Fine Arts. Theodora Wilbour Fund in Memory of Charlotte Beebe Wilbour. 59.297.*

**36**

**Silver standing Apollo,** laureate, with bow in left hand, quiver behind right shoulder; most of right hand missing. H. 0.047 m. Boston, Museum of Fine Arts, 59.297. C. Vermeule, *CJ* 58 (1962) 7, fig. 7. The ultimate prototype belongs to the art of Skopas or Praxiteles about 350 B.C. Cf. the head from a statuette: Walters, British Museum *Silver Plate,* p. 11, no. 37, fig. 8.

**37**

**Silver standing Phrygian Dionysos-Sabazios.** He wears a long chiton, shoes, and a full himation with over-fold arranged in an archaistic fashion. A phiale is held in the lowered right hand and a cornucopia in the left; he is bearded and appears to have a fillet in the hair, tresses on either shoulder. Small plinth. H. 0.034 m. Boston, Museum of Fine Arts, 1971.142; said to come from Asia Minor. The figure appears on the front corners of Dionysiac sarcophagi, as the Casali example in Copenhagen: K. Lehmann-Hartleben, E. C. Olsen, *Dionysiac Sarcophagi in Baltimore,* Baltimore 1942, fig. 40.

**38**

**Silver standing Asiatic Dionysos(?).** He stands on a small plinth that has two indentations in the bottom, for soldering on a larger surface, such as the floor of a small shrine(?), in a sanctuary or temple. A phiale is in the extended right hand, and a bunch of grapes(?) is held against his left side in his left hand. H. 0.05 m. West Barnstable (Mass.), collection of Richard R. Wagner. From the region of Urfa and Diyarbakir in southeast Asia Minor, toward the Syrian border. The statuette probably dates in the second or early third century A.D., perhaps between A.D. 120 and 220. It was found with identical statuettes in bronze and with other bronze examples of a much more schematic, provincial nature, all suggesting that they came from a sacral area where a Hellenistic form of a fully clothed, bearded Dionysos served as the cult image. The god has a head based ultimately on the fourth century B.C. (Bryaxis?) prototype of

the Zeus from Otricoli. He wears a short-sleeved chiton and a himation, the large folds of which (over the left shoulder and around the waist) have a border of stylized grooves and chevrons. (The section above the left hand almost looks as if the god were clutching a palm branch in his hand, with the grapes.)

## 39

**Silver seated Hermes,** on a rock on which he rests his left hand; his right on the right knee holds a purse; wings on the head. H. 0.052 m. Boston, Museum of Fine Arts, 03.771. Ch. Picard, *Manuel d'archéologie grecque, La Sculpture,* IV, 2, Paris, 1963, pp. 595f., as a Lysippic figure known in a number of replicas; F. P. Johnson,

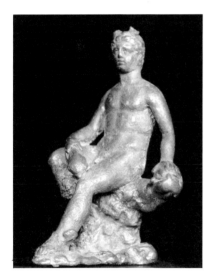

39. Hermes seated on a rock. Silver, Graeco-Roman. *Boston, Museum of Fine Arts. Francis Bartlett Collection. 03.771.*

*Lysippos,* Durham, N.C., 1927, p. 178, no. 7 in a list of replicas and variants that begins with the large bronze from Herculaneum, in Naples. For further discussion of this attractive Hermes, of which this example in silver is unusual, see J. M. C. Toynbee, *Art in Roman Britain,* London, 1962, pp. 132f., esp. fig. 236, under no. 20; M. Bieber, *The Sculpture of the Hellenistic Age,* New York, 1961, p. 41, figs. 106–108.

## 40

**Silver Hermes** of Polykleitan type, in its Roman derivative form, standing with purse in extended right hand, an uncertain object (not apples?) on the left. A cloak is around the shoulders and left arm, as in statues of Roman emperors; wings were on the ankles. Reinach, *Rép. stat.,* IV, p. 88, no. 2; cites *Vente Hertz* (1851), pl. 4, 3.

## 41

**Silver Hermes,** as the preceding. Purse in the lowered right hand, a caduceus was in the left (so also the above[?], the fingers having been made to resemble apples). Cloak on left shoulder and around left arm, doubled over with a brooch. In or from Lyon. Reinach, *Rép. stat.,* IV, p. 89, no. 5, with no previous publication given.

## 42

**Silver Herakles** based on a famous Pergamene statue. H. 0.05 m. New York, Metropolitan Museum of Art, 11.91.2. The figure wears a crown with fillets on the shoulders. He

42. Herakles of Pergamene type. Silver, Graeco-Roman. *New York, Metropolitan Museum of Art.*

stands on a plinth in the form of an irregular oval or rough square extending far enough to the right to leave room for another figure or object. This looks like four little feet and could thus be a group composed of Herakles holding Telephos, with the hind standing beside him, looking upward. Telephos would be on the left arm and a phiale could be in the lowered right hand. Since the lion's skin is not present, there would be no special necessity to show the club. Telephos with Herakles: see Roscher's *Lexikon,* I, 2246f., citing a bronze: *Coll. J. Gréau, Cat. des bronzes antiques,* Paris, 30–31 May

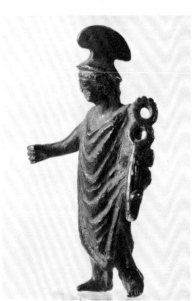

1885, pp. 74f., pl. 8, no. 347: a young Herakles with Telephos on the left arm, a lion and hind and the eagle (as the Pergamene fresco) at his feet on the left, his club in the lowered right hand; the position of the legs is the same. Related are the colossal marble Herakleses at Wilton House and in the Metropolitan Museum: *AJA* 59 (1955) 149, pl. 45, fig. 28; G. M. A. Richter, *Catalogue of Greek Sculptures,* Cambridge (Mass.), 1954, pp. 73f., no. 121, pl. XCIII.

### 43.
**Silver Hermes,** in long traveler's cloak, crested cap, and with wings (once) on the ankles; he holds a caduceus in his left hand, a purse having been in his extended right. H. 0.07 m. Boston, Museum of Fine Arts, 67.860, from Asia Minor. C. Vermeule, *The Burlington Magazine* 113 (July 1971), 403f., figs. 53, 54. The type is well known in bronze, from all over the Roman world: e.g., two from a temple site at Bruton, Somerset: J. M. C. Toynbee, *Art in Roman Britain,* p. 134, nos. 22, 23, pls. 13, 14, 21, 22. Compare, especially, the bronze of about the same height and with similar details: *Verres et bronzes antiques, Ancienne collection J.-A. Durighello,* Paris, 16 May 1911, p. 35, no. 325, pl. XIII.

### 44
**Headless silver Hermes,** type of the M.F.A. bronze 98.676: *Greek, Etrus-*

43. Hermes in traveler's costume. Silver, Graeco-Roman. *Boston, Museum of Fine Arts. Gift of Miss Mary B. Comstock. 67.860.*

*can, and Roman Art,* p. 260, fig. 244, the purse in his extended right hand. Hospice de Beaune. Reinach, *Rép. stat.,* IV, p. 94, no. 5.

### 45
**Gold Hermes,** with traveler's cloak, purse, and large caduceus. H. 0.05 m. New York, Royal-Athena Galleries, from Rome. Reinach, *Rép. stat.,* IV, p. 95, no. 4; *Succession de Mme E. Warneck, Catalogue des objets d'art,* Paris, Hôtel Drouot, 3, 4 May 1905, p. 33, no. 227, pl. XIV. The features of this votive statuette from a family shrine appear to be those of Gaius or Lucius Caesar, if not of Augustus as Novus Mercurius. This is the foremost of the several Graeco-Roman Hermeses in gold. Variants of the type are found widely in bronze.

### 46
**Silver Hermes,** of the classical Polykleitan type, standing with caduceus (once) in the extended left hand, purse in the lowered right. A small ram(?) is at his right foot, a petasos on the head, and a cloak on the left shoulder, over the left arm. Bonn, Provinzialmuseum, no. 19 843; from "Der Bonner Silberfund": Bonn, Coblenzer Strasse. H. Lehner, *Führer durch des Provinzialmuseum in Bonn,* 2nd ed., I, Bonn, 1924, p. 106, pl. XIX. This statuette recalls well-known Graeco-Roman copies in marble, statues life-sized or over: Kourion, Salamis on Cyprus, etc. See *Bulletin de correspondance hellénique* 93 (1969) 561, fig. 199; *AJA* 74 (1970) 74, pl. 21, fig. 14.

**47**

**Silver statuettes of Hermes from the Macon Treasure.** Three representations of Hermes in silver from the Macon Treasure found in a vineyard in 1764 with 30,000 imperial aurei and denarii, none later than Gallienus (A.D. 253 to 267). Three representations of Hermes follow famous prototypes of the fifth and fourth centuries B.C. There are two replicas of one figure (Walters, British Museum *Silver Plate,* p. 9, nos. 30, 31), making a total of *four* statuettes, three having ancient circular or hexagonal bases. No. 29 is of monumental conception, in the Polykleitan tradition, with wings over the forehead, a wreath in the hair, a cloak around the neck and over the left arm, purse in the left hand, and evidence of a caduceus in the right, lowered and extended. The cock at the left foot reflects a further addition of the Graeco-Roman copyists. H. (with base) 0.14 m. Nos. 30 and 31 are considerably smaller, each about 0.08 m. with base. They also reflect what could be a type of the Polykleitan circle, but what is more likely a creation leading thence to the so-called Hermes of Praxiteles in the middle of the fourth century B.C. No. 32, bereft of its base, is also 0.08 m. high and shows Hermes wearing a winged petasos, putting his right hand to his head in the gesture of Herakles or an athlete crowning himself, and evidently once holding his caduceus in his extended left hand. The position of the cloak as well as the heavy anatomy combined with Hellenistic head make this more definitely an eclectic creation of the early imperial period, like statues of rulers in heroic guise. However, the features show no portrait qualities.

**48**

**Gold Hermes,** with the features of the Emperor Tiberius (A.D. 14 to 37). He wears a cloak around the shoulders and the left arm to the elbow and holds a purse in the lowered right hand, a caduceus against the shoulder in the left. H. 0.04 m. Athens, National Museum, Madame H. Stathatos Collection. P. Amandry, *Collection Hélène Stathatos,* III, Strasbourg, 1963, pp. 235f., no. 171, pl. 36, fig. 140 (details). Although no base is preserved and the figure moves in a Polykleitan walking pose, this could be from the top of a pin rather than a votive statuette, but the austere nature of the head precludes this as subject for jewelry (for all but the most forthright of females).

**49**

**Gold Hermes,** similar but without portrait features and also early Roman imperial. H. 0.043 m. Switzerland, art market, in 1964. Now (1971) in a Swiss private collection (information from Dr. L. Mildenberg). Ars Antiqua, Auktion V, Lucerne, 7 November 1964, p. 39, no. 152, pl. XLI. He holds a long caduceus like a herald's staff in his right hand, a small purse in the lowered left; the conventional cloak appears around the left shoulder and on the left arm to just above the wrist. Lucerne sale no. 153, illustrated on the same plate, are described as gold earrings in the form of standing Aphrodites, being in fact rough mirror reversals based on the celebrated Praxitelean Knidia. They comprise admirable demonstrations of the closeness between statuettes in gold and figured jewelry, as does a nude Aphrodite in silver holding up her tresses, in the Stathatos Collection: Amandry, III, p. 235, no. 170, pl. XXXVI.

**50**

**Hermes Nomios or "shepherd" in silver.** Best described verbatim: "A boyish figure, . . . wears a chlamys fastened over the shoulders, a chiton reaching to the knees and high boots leaving the toes bare. In l. hand he holds a bottle of skin suspended from the shoulder, and at the back, suspended from the brooch which fastens the chlamys, is a large bag or pouch of skin, in which is a sheep (head and forelegs visible)." The right hand is broken away. H. 0.08 m. London, British Museum. Walters, British Museum *Silver Plate,* p. 14, no. 55, pl. VI and fig. 14 (which provides a good view of the head). The face, viewed frontally, is young, seemingly ideal, but hardly divine or heroic in the abstract. A sense of personality speaks even in such a small face. The view in profile may provide an identification, where the long neck, small chin, and rectangular Julio-Claudian head make it probable that the young prince as Hermes Nomios is the (future?) emperor Claudius (A.D. 41 to 54).

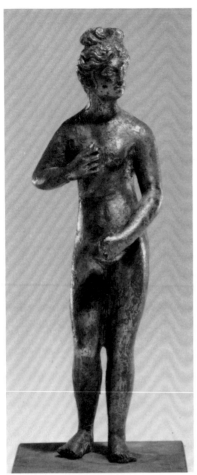

52. Aphrodite, Capitoline type. Silver, A.D. 175-250. *Boston, Museum of Fine Arts. Edward J. Smith Collection. 288.1970.*

**51**

**Silver athlete.** In this realm of divine and athletic statuettes based on Greek models of the second half of the fifth century B.C. belongs an athlete in silver, perhaps a young god or hero, much admired in the Basel art market in recent years. The dimensions were very small. Münzen und Medaillen A.G., Basel.

**52**

**Silver Aphrodite,** Capitoline type, to be dated on comparison with major sculptures and portraits in semi-precious stones, on small scale, between A.D. 175 and 250. H. 0.115 m. Boston, Museum of Fine Arts, loan no. 288. *1970.* Collection of Edward J. Smith, Forest Hills, New York; once at the Royal-Athena Galleries, New York. *Archaeology* 13 (1960) back of front cover: "Eastern Mediterranean." This is an arresting work of art that cannot be described in the usual verbiage about the Graeco-Roman ideal nude; the details provide poor descriptive copy, but the total effect gives a sense of why Roman patrons of the later imperial period sought small silver as their medium of admiration when they could have been satisfied with larger, gilded bronzes. The head and upper body are particularly graceful, but the lower limbs seem awkward and inarticulate. Compare the silver "Knidia" in Walters, British Museum *Silver Plate,* p. 11, no. 38. The height (0.127 m.) is nearly the same. This was a much admired, reused Roman image.

**53**

**Silver Aphrodite.** Alexandria (Egypt), Museum. This information was supplied by a colleague, a scholar, who visited the Alexandria Museum in the late 1960's. He may have been referring to the [inventory number] "1889: Gold: Small image of *Venus Anadyomene,*" listed on p. 168 of Ev. Breccia, *Alexandrea ad Aegyptum,* Bergamo, 1922.

**54**

**Gold Aphrodite and Eros.** H. 0.027 m. W. 0.013 m. Brooklyn (New York) Museum, no. 36.173. "Collection in Salonika. Acquired in Monastery of Lavra on Mt. Athos" (Charles T. Seltman). L. W. Chase, "New Byzantine Acquisitions," *The Brooklyn Museum Quarterly* 23 (July 1936), 141, fig., as Byzantine VIIIth century, from the lid of an imperial lady's casket. Miss Biri Fay, curatorial assistant, in a personal communication (January 1972) stated: "cast solid and standing on a flat plate. Torch in left hand of Venus, the right hand raised to her head which bears a wreath. Cupid with bow and quiver stands at right angle to Venus. A dove at their feet." "If ancient, a late Hellenistic date is probable, possibly around first century B.C." The piece has stylistic affinities with Late Antique, so-called Coptic bronzes from Egypt. It also looks like some of the German and Northern Italian seventeenth century sculptures made in the manner of the Antique.

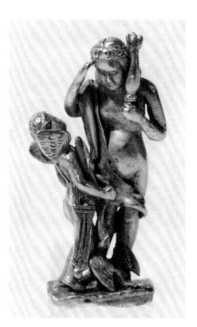

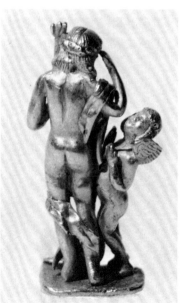

**55**

**Gold "Isis-Tyche,"** an unusual pantheistic divinity with a head of Aphrodite, the costume of Isis, and the cornucopia of Tyche-Fortuna. H. 0.0525 m. Geneva, Musée d'Art et d'Histoire, no. 20237. From the ancient collection of Prince Juvitzky-Warberg. "Signalée, *Genava* n. s. XIII, 1965, p. 215 — où il faut supprimer la dernière dimension, qui concerne la pièce précédente — et illustrée sur la couverture des *Musées de Genève,* no. 52, février 1965." Information and photograph from the curator, Christiane Dunant. The circular base with beaded borders recalls the moldings of Roman jewelry. The statuette ought to belong to the Roman imperial period and date from the second or third centuries A.D., but the lower drapery and pose of the feet have an Italian Baroque look, and the strap wrapped around the cornucopia is without evident parallels. Since many Roman imperial statuettes in gold and silver, particularly those from the western provinces, incorporate unusual features and have been conceived in almost bizarre styles, the seventeenth century qualities of this "Isis-Tyche" may be merely the ancient sculptor's interpretation of the Antonine or Severan baroque.

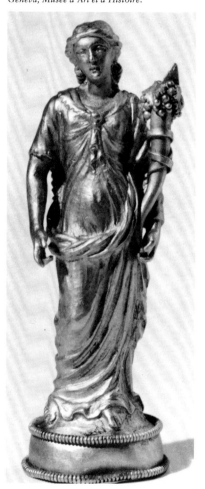

55. Pantheistic "Isis-Tyche." Gold, ca. A.D. 200. *Geneva, Musée d'Art et d'Histoire.*

54. Aphrodite and Eros. Gold, Coptic or Northern European, seventeenth century. *Brooklyn Museum.*

**56**

**Gold Eros,** standing at a column and holding an apple in his raised right hand. H. 0.025 m. Collection of D. L. Davis; from Athens. J. Chittenden and C. Seltman, *Greek Art, A Commemorative Catalogue of an Exhibition held in 1946 at the Royal Academy Burlington House London,* London, 1946, p. 44, no. 294, pl. 74. A tiny votive (?) figure on a flat platform-plinth (copying large bronzes of the late Hellenistic period), this statuette can be dated from the late Hellenistic period to the late first or early second centuries A.D. It belongs to those very small works in the precious metals related to earlier Greek platformed pinheads. This figure has its perfect counterpart in the sculpture of gold earrings, as an example with Eros holding a phiale and short staff, garland-sash across his chest: *Ancient Jewellery, Antiquities, Gold Medallions and Coins,* London, Christie's, 19 October 1970, p. 41, no. 116, illustrated. One also recalls, in this connection, the dedications by Chryseros at Sardis: C. Vermeule in *Essays in Memory of Karl Lehmann,* New York, 1964, pp. 359f., note 3.

**57**

**Romano-Egyptian gold statuette** of Harpokrates-Herakles with a club. H. 0.075 m. Lucerne Art Market, 1962. Ars Antiqua, Auktion IV, 7 December 1962, p. 7, no. 10, pl. V: cites another in H. Schäfer, *"Ägyptische Goldschmiedearbeiten,* Berlin, 1910, p. 83, no. 139, pl. 19. K. Parlasca,

"Herakles-Harpokrates und Horus auf den Krokodilen," in *Akten des 24. Internat. Orientalistenkongresses in München,* 1957, p. 71, pl. IX. This figure is fashioned out of gold sheeting about ½ mm. thick. He wears a long tunic and an elaborate Egyptian headdress and stands on a small, circular base. He is the counterpart of the bronze Horus-Harpokrates found at Taxila: M. Wheeler, *Roman Art and Architecture,* New York, 1964, p. 223, fig. 207.

**58**

**Artemis-Selene,** in gilded silver and on an ancient, circular base. The attributes are missing, but a crescent remains over her forehead. H. 10 m. (including base). London, British Museum, from the Macon Treasure. Walters, British Museum *Silver Plate,* p. 9, no. 28, pl. VI. This Artemis anticipates the Late Antique qualities of the goddess with windblown drapery, in Boston, to be discussed presently. Since the latest coins found with the Macon statuettes are Gallienic, this would accord well with the face and somewhat awkward pose of the Artemis-Selene.

**59**

**Silver genius,** wearing a mural crown, himation around the waist, and "divus" boots, a phiale in the extended right hand and a cornucopia in the left. H. 0.095 m. (including base). London, British Museum, from the Macon Treasure. Walters, British Museum *Silver Plate,* p. 10, no. 34, pl. V. This typically Roman imperial

statuette forms a stylistic complement to the elaborate Tyche or Personification of a City (suggested as Massalia), the last Macon figure considered here.

**60**

**Gilded silver Tyche or personification of a city,** the most complex single figure in the precious metals surviving from classical antiquity. The divinities personifying the days of the week appear on the crescent above the mural crown, the Dioskouroi on the wings that support the crescent, and two further divinities (Apollo, Artemis) as busts springing from the twin cornucopiae. The wreathed altar beside the Tyche's right foot can be traced from Hellenistic (dove earrings) into later Roman jewelry and precious metalwork. H. (with base) 0.14 m. Walters, British Museum *Silver Plate,* pp. 9f., no. 33, pl. V. A Hermes in bronze from Autun shows a similar piling-up of these calendrical attributes: *Revue archéologique* 1900, pp. 220ff., pl. XII; Reinach, *Rép. stat.,* III, p. 53, no. 2.

**61**

**Tyche or personification of a city,** in silver, pouring a libation with a large phiale in the right hand. She appears to have held a cornucopia in the left. H. 0.08 m. Geneva, Musée d'Art et d'Histoire. Inv. no. C 1731. Found at Bonneville (Haute-Savoie, France). Reinach, *Rép. stat.,* V, 1, p. 110, no. 4; cites W. Deonna, in *Revue archéologique* 1912. II, p. 38, no. 6 and called a Fortuna (line drawing). Also, W. Deonna, *Catalogue des bronzes*

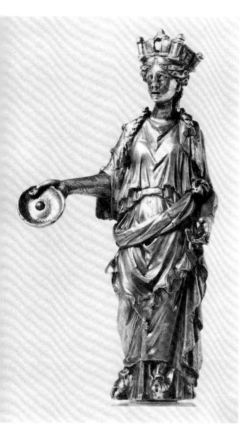

61. Tyche. Silver, ca. A.D. 200.
*Geneva, Musée d'Art et d'Histoire.*

*figurés antiques du Musée de Genève,* in *Indicateur d'antiquités suisses,* n.s. 17 (1915) 287, no. 55; *L'Art dans l'occident romain,* no. 25 (catalogue d'exposition, Paris, Louvre, 1963). The figure, clad in loose chiton and himation, is of a type found more than once in the silver "treasures" from Gaul. Indeed, chiton with over-fold and himation are similar to those of the Macon Tyche. The iconography and details can be paralleled on an over-life-sized scale in marble and (presumably once) in the precious metals. Compare the Macon Treasure Tyche, (position of arms, type of crown, phiale), the male "Genius" from the same find, and the smaller Tyches discussed below. This figure could have come from the same workshop as the Macon statuettes. The bronze Pantheistic Tyche from Asia Minor, in Boston (67.1036), is a comparable type of figure, one showing the thin line between styles and materials in smaller Graeco-Roman sculpture: C. Vermeule, *BMFA* 68 (1970) 211, fig. 19a.

**62**

**Hera-Juno,** veiled (the himation pulled over the head), with the high-girt chiton; of the Hera Chiaramonti type of the fifth century B.C. This statuette has been identified as a: Tyche, "Roman, Small Statuette of a Goddess, Silver." Cambridge (Mass.), Fogg Art Museum. 1942.233. ex collection of Paul J. Sachs. *Memorial Exhibition, Works of Art from the Collection of Paul J. Sachs (1878–1965),* Cambridge (Mass.), 1965,

p. 199. A patera was doubtless in the extended right hand and a scepter-staff in the raised left. The date is about A.D. 150 to 250 and the image may have been part of a group portraying the Capitoline Triad, Jupiter seated between Juno and Minerva. The quality is good, and there is considerable feeling for the monumentality of the prototype. It is easy to see this statuette as having been part of a portable shrine, either in a household or in the baggage of an officer in the legions.

**63**

**Statuette of Fortuna,** in gilded silver. "Petite Fortune en argent doré, la corne d'abondance au bras gauche. H. 0.034 m. La main droite manque." *Collection Joseph de Rémusat,* Paris, Hôtel Drouot, 17–18 May 1900, p. 30, no. 283. No. 284 in the same sale is listed merely as "Argent, Fortune."

62. Hera. Silver, ca. A.D. 200.
*Cambridge (Mass.), Fogg Art Museum.*

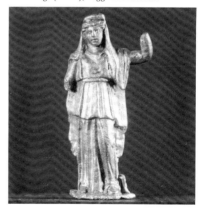

**64**

**Tyche-Fortuna in gold,** Roman imperial period, second century A.D. H. 0.165 m. New York (?), Collection of Walter Chrysler, from the Royal-Athena Galleries, Basel Art Market, and, ultimately, North Africa. H. A. Cahn, *Kunstwerke der Antike, Auktion 34,* Basel, Münzen und Medaillen A.G., 6 May 1967, p. 114, no. 220, pl. 76. The head is said to have the features of a portrait, perhaps the empresses Faustina II (died 175) or Julia Domna (193 to 215). All of history and the visual arts (the reverses of the larger Antonine orichalcum and copper coinage) combine to indicate that a statue such as this, however beaten and battered (and mold cast and chased), is a direct, material reflection of the Tyche-Fortuna that was the tangible symbol of imperial power in the grand days of the Antonine emperors, the statuette described in the Antonine and Severan biographies of the *Historia Augusta.* The figure is the golden counterpart, with variations in the drapery, of the silver Fortuna from the Chaource Treasure, dated by the accompanying coins to the period from Domitian through Antoninus Pius. This would correspond to the high point of the cult of the golden Fortuna in Rome. (See next entry.)

**65**

**Tyche-Fortuna, in gilded silver,** on a turned silver base of hexagonal shape, the top and bottom molded and ornamented. This diademed figure, cornucopia on the extended left hand,

is rough and Roman, provincial in details, but the (somewhat-mannered) drapery betrays a famous Pheidian prototype, a Hera or Demeter, of the period around 430 to 400 B.C. H. (with base) 0.165 m. London, the British Museum. Found in a field at Chaource near Montcornet, Department of Aisne, France. Walters, British Museum *Silver Plate,* p. 38, no. 144, pl. XXIII. With this was found the patently Hellenistic or Hellenistic-inspired silver, partly gilded, "pepper-castor" in the form of a seated, sleeping watchman of African ancestry.

**66**

**Tyche-Fortuna,** of the most conventional type, silver. H. 0.05 m. Paris, Musée du Louvre. A. De Ridder, *Catalogue sommaire des bijoux antiques,* Paris, 1924, p. 206, no. 2090, pl. XXIX. She wears the diadem on her head and holds the horn of plenty in her left hand. The lowered, extended right hand is missing. The figure is slightly elongated, but the style is good. To be dated in the period about A.D. 150 to 300, the ultimate prototype was the famous image of Fortuna belonging to the imperial family.

**67**

**Tyche-Fortuna in silver** (?). "femme sacrifiant" (a patera in the right hand and the left arm missing). *Rodin collectionneur,* Paris, 1967–1968, no. 228, fig. 88 (reference kindness of Professor J. Frel). H. 0.13 m. The model is Greek, about 350 B.C.

**68**

**Tyche-Fortuna in gold,** with polos on her head (and loop for suspension). Nicosia, the Cyprus Museum, no. J 738. H. 0.013 m. A. Pierides, *Jewellery in the Cyprus Museum,* Nicosia, 1971, 34, no. 7, unknown provenance. She holds the cornucopia in her left hand, a phiale-patera in the lowered right. She wears the fringed cloak of Isis, or an elaborate long necklace, and stands on a small plinth of Antonine type. The face suggests an Antonine or Severan dating; perhaps the piece is even later. She appears also to have a stud (or casting point) in the middle of the back.

**69**

**Tyche-Fortuna in silver.** Baltimore, Walters Art Gallery, no. 57.1480. H. 0.063 m. *Succession de Mme E. Warneck,* Paris, Hôtel Drouot, 3, 4 May 1905, p. 34, no. 230. "L'Abondance debout, drapée, la coiffure ornée des attributs d'Isis, tenant de la main gauche une corne d'abondance et de la main droite une patère. Statuette de laraire en argent." Her face is like portraits of Faustina II (died A.D. 175), and this Isis-Tyche-Fortuna ought to date in the late Antonine or Severan periods. The style of her hair also suits these dates.

**70**

**Goddess or personification in gilded silver.** H. 0.045 m. Baltimore, Walters Art Gallery, no. 57.1578. *Succession de Mme E. Warneck,* Paris, Hôtel Drouot, 3, 4 May 1905, p. 34, no. 231.

"Femme debout, diadémée et drapée, tenant de la main droite un miroir et de la gauche un bouquet de pavots [poppies]; à ses pieds, une ciste. Statuette de laraire en argent doré."

## 71

**Silver statuette of Aphrodite,** drapery around her lower limbs, which she holds with her left hand, an apple in her extended right hand. Roman imperial period, probably from one of the western provinces. H. 0.185 m. New York, Collection of Christos Bastis, ex New York Art Market, Mathias Komor. The work has the look of bad casting, crude chasing, and generally hesitant finishing. The hair and face reflect a prototype of the fourth century B.C., while the body, himation, position of the hands, and attribute go back to models in the second half of the second century B.C., specifically the period of the Aphrodite of Melos; see M. Bieber, *The Sculpture of the Hellenistic Age*, New York, 1961, pp. 159f., figs. 673–677. The general forms, strangely enough, can be related to the figure of a "Rhodian" Hermaphrodite, the originals of which have been dated in the period of the Nike of Samothrace; Bieber, pp. 124f., fig. 492.

## 72

**Gold statuette of Hygeia.** "An Alexandrian small gold Figure of a Goddess, a scale pattern on the upper part of her long tunic, carrying a staff in her left hand and a thyrsus in her right, a snake curling up from her wrist to the left side of her face, standing on a rectangular pedestal, 1⁵⁄₈ in. (4.1 cm.), c. 3rd Century A.D." Sotheby Sale, 4 May 1970, p. 18, no. 52, with illustration. This statuette appears to be a pantheistic Hygeia, a reflection in miniature of a typical Alexandrian imperial cult-statue based on models going back to the fifth and fourth centuries B.C. The craftsmanship seems excellent.

## 73

**Silver goddess ("Circe"),** with a votive pig on a rectangular plinth at her feet. Graeco-Roman, presumably from the western provinces. There is a veil (?) over the back of her head and a double torque-like necklace around her neck. H. 0.22 m. She appears to be made in half molds, like a pastry, and is doubtless hollow within. New York, Art Market, Mathias Komor. Such divinities are found in Gaul and are local manifestations or assimilations of Demeter. This "goddess" could be a local geographical (river ?) divinity, with the votive animal in front of her. Compare the following example, the Musée de Mariemont statuette. The pig can be compared, with profit, to the votive statuette of a wild sow in Hamburg, which has been said (see above) to be Greek of the fifth or fourth centuries B.C.

## 74

**Gallo-Roman statuette of a goddess in silver,** second or third centuries A.D. H. 0.235 m. H. (of socle) 0.026 m. The figure is made of heavy silver leaf, beaten into a mold; the right arm is of silvered bronze, with the edges crimped behind. Musée de Mariemont. Found in 1902 near the choir of the church of Saint-Honoré-les-Bains, in the Nièvre (Aquis Alisencii). *Les Antiquités Égyptiennes, Grecques, Étrusques, Romaines et Gallo-Romaines du Musée de Mariemont*, pp. 170f., no. F 13, pl. 60; Reinach, *Rép. stat.,* IV, p. 139, no. 3. Identified as the goddess of the source of the local waters, this class and type of figure are Gallic imitations of statues of Demeter-Ceres, Tyche-Fortuna, or Nike-Victoria. This particular statuette is like a Hera or Demeter of the fourth century B.C., or a Tyche derived therefrom. It gives the appearance of being a sleek but lifeless work.

## 75

**Goddess,** in "core cast silver with two gold bracelets and a gold necklace." Height given as "10¾″ (with base)" (0.273 m.); width as 3¹³⁄₁₆″ (0.096 m.). Toledo (Ohio) Museum of Art, acc. no. 71.131. *The Art Quarterly* 35 (1972), 435, 444, fig. 3 (top). The base or turned, molded plinth may or may not belong. The date given ("3rd century B.C.") should read late second or third century A.D. She is the standard Roman imperial goddess with diadem, chiton and full himation draped around the waist and over the left arm. The lowered left hand held an uncertain attribute, perhaps a scepter-staff, and it is difficult to say (the apple of Venus?) what was intended for the raised,

extended right hand. The quality of this figure is excellent, and the style of wavy hair divided over the forehead and flowing either side of the diadem is that of the younger, later ladies of the Antonine imperial family. This Juno, Venus, or Salus (with snake and staff) could be an idealized portrait of Faustina II about A.D. 160 or her daughter Lucilla in the decade which followed. If designed for a chapel to the Antonine and Severan ruling houses, the date could have been as late as the death of Severus Alexander, in A.D. 235. The intensity of the figure's gaze, head bent toward her raised right hand, could be explained if she were Salus-Hygeia feeding a snake out of a patera in her right hand. A cult-statue in this pose appears on a number of Roman imperial coins in the second century A.D. This statuette is larger than the average Graeco-Roman cult-figure in silver or gold. It must have been an important dedication. Kurt T. Luckner, Curator of Ancient Art, reports that the base or plinth is modern. The statuette came from the De Clercq collection: A. De Ridder, *Collection De Clercq,* III, *Les Bronzes,* Paris, 1905, pp. 201–202, no. 291, pl. 46 (as Faustina or Hera ?).

## 76

**Goddess identified as Demeter-Ceres,** silver, a somewhat-rustic, Gallo-Roman (?) figure based ultimately on one of the grand statues of the fifth century B.C. H. 0.253 m. Paris, Musée du Louvre, from Tortose. A. De Ridder, *Catalogue sommaire*

*des bijoux antiques,* Paris, 1924, p. 206, no. 2089, pl. XXVIII. The figure stands on its ancient, circular, molded pedestal; the goddess wears chiton and himation. Attributes in the lowered hands are missing. The ultimate prototype belonged to the era of the original of the Hera Borghese, in the Ny Carlsberg Glyptotek, Copenhagen.

## 77

**Silver statuette of Cybele** ("Dea Caelestis") riding on a lion. H. 0.052 m. L. 0.044 m. Basel, Münzen und Medaillen A.G., on deposit (January 1972) in the Museum of Fine Arts, Boston, 1972.45. Helen and Alice Colburn Fund. Cybele is seated on the right side of a galloping lion, a small tympanon or drum in the left hand and the end of her himation in

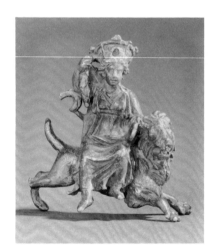

77. Cybele on a lion. Silver, ca. A.D. 200. *Boston, Museum of Fine Arts. Helen and Alice Colburn Fund. 1972.45.*

the raised right. She wears a rich mural crown on her head, with windows and extra battlements above. The end of the animal's tail curls up to her right elbow and is also supported by a *puntello* to the edge of the himation. The lion has a full, rich mane, and additional fur on the body is represented by modeling and incision. The form of the goddess' head and the arrangement of the hair indicate that this statuette dates in the Antonine period or later.

A figure similar to this graces the coins of Septimius Severus and his family, the inscription referring to their benefactions to Carthage in their native North Africa. The tympanon is held in the right hand and a scepter-staff in the left. The style of the animal is identical to the silver statuette on at least one die; see H. Mattingly, *Coins of the Roman Empire in the British Museum,* V, *Pertinax to Elagabalus,* London, 1950, p. 208, pl. 34, nos. 2, 3: Caracalla, A.D. 201–206. The goddess is called Dea Caelestis. That this silver statuette is based on monumental sculptures popular in Italy and the Latin West is evident from a marble statue in the Villa Doria-Pamphili in Rome. As here, the right hand (restored) held up the end of the himation. The Pamphili statue comes, it is said, from Nettuno, and such figures appear to have been set as cult images on the spinae of circuses; F. Matz, F. von Duhn, *Antike Bildwerke in Rom,* I, Leipzig 1881, p. 241, no. 902; Reinach-Clarac, *Rép. stat.,* I, p. 182, no. 4. This might suggest

the little silver Cybele on her lion was the personal household image of a prosperous charioteer in the later Antonine or Severan periods of the Roman Empire.

## 78

**Pantheistic Ariadne,** silver with traces of gilding, a cornucopiae on the left arm, the right arm raised behind the head in memory of the famous Hellenistic statue (identified as Ariadne). L. 0.05 m. Once New York, the Brummer Gallery. *Early Christian and Byzantine Art,* the Walters Art Gallery, Baltimore, 1947, p. 80, no. 355, pl. L. The figure was badly cast, in a good style but with blurry surfaces. She is clothed in the drapery of the Hellenistic (Pergamene) bronze or marble, surviving in a number of Graeco-Roman copies. In addition, she wears the animal's skin of Dionysos or one of his followers, notably the satyrs, across her chest. "Ariadne" (or a maenad) appears to recline on a rockwork throne or seat, and a female panther crouches beside her, to assure the identification as a Dionysiac figure. "Ariadne"'s head is encircled with a broad fillet in which are vine leaves and bunches of grapes. The cataloguers of the Baltimore exhibition termed the statuette "Gallo-Roman, 4th cent.," but she might well date in the second or third centuries A.D. A Gallic provenance is natural in view of the high proportion of silver statuettes found there, and the Roman imperial parallels are among comparable small bronzes of reclining geographical personifica-

tions and even the secondary figures in large, marble sarcophagus reliefs.

## 79

**Standing goddess in gilded silver.** She wears a large diadem, a slipped high-girt chiton, and an ample himation; she leans against a square pillar that rises to the left elbow. A scepter was held in the raised right hand and another object, perhaps a phiale, on the extended left. A large hole in the back has been filled in with shellac. H. 0.124 m. Acquired in London by E. P. Warren; said to have come from Asia Minor. Boston, Museum of Fine Arts, 01.8187. H. L. Pierce Fund. The type is well known in bronze as the "Venus" in the Bibliothèque Nationale demonstrates; E. Babelon, J.-A. Blanchet, *Catalogue des bronzes antiques de la Bibliothèque Nationale,* Paris, 1895, p. 115, no. 264 (also called "Juno").

## 80

**Statuette of a goddess** standing at a column, in silver. A phiale was probably on her extended left hand and a scepter-staff (or a kantharos?) in her raised right. Her diadem is slightly smaller than that of the preceding statuette, and it is questionable whether the round, conventionally-molded base belonged to the original, as it seems to leave little room for the scepter-staff, unless the latter was allowed to wave in the air. This statuette seems to be Roman imperial, of the second or early third centuries A.D. H. 0.197 m. New York art market, Mathias Komor. Compared

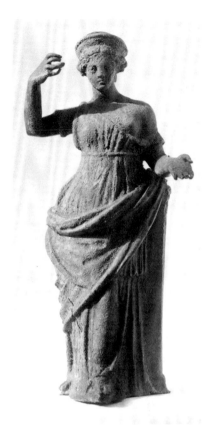

79. Goddess. Gilded silver, Graeco-Roman. *Boston, Museum of Fine Arts. H. L. Pierce Fund. 01.8187.*

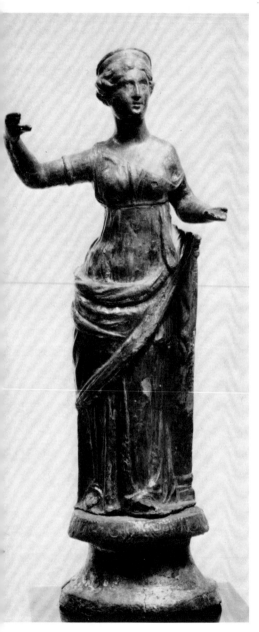

with the preceding statuette, which is a creation of Hellenistic quality as well as late Greek eclectic style, this silver statuette shows the aesthetic or qualitative variation that can exist in two statuettes based on the same ultimate model, one with antecedents in both the fifth and the fourth centuries B.C. So also the bronze once in the Metropolitan Museum; Anderson Galleries Sale, 30, 31 March 1928, p. 481f., no. 479.

## 81
**Graeco-Roman silver statuette** of Harpokrates, "a detailed representation and quite charming," in the usual idiom (Andrew Oliver, Jr.). H. 0.034 m. New York, the Metropolitan Museum of Art, Acc. no. 23.160.30. This is a lively version of the type, preserving the Praxitelean reminiscences of the torso, which is turned like the Apollo Sauroktonos or a young satyr. The zoological life at the feet appears to have been reduced to the dog, the tortoise, and a serpent climbing the support from the bottom of the cornucopia. The puckish, boyish aspects of the young god are well brought out.

## 82
**Graeco-Roman gold statuette of Harpokrates,** standing, with small wings, holding a cornucopia, wearing the "'crowns of the North and South' with a crescent in front," and

80. Goddess. Silver, ca. A.D. 200. *New York, Mathias Komor Collection.*

82. Harpokrates. Gold, Graeco-Roman. *Boston, Museum of Fine Arts. John Michael Rodocanachi Fund. 1971.139.*

flanked by a dog and an eagle (?). A serpent is coiled at the back, with its head visible above the left shoulder; the tiny statuette is set on a small, rectangular plinth, which has been bent upward on the left and right. H. 0.019 m. Boston, Museum of Fine Arts, 1971.139. John Michael Rodocanachi Fund. Compare the British Museum example, also with small wings; Walters, British Museum *Silver Plate,* p. 12, no. 47, fig. 10.

## 83
**Graeco-Roman gold statuette of Harpokrates,** standing in canonical pose, also with small wings; he holds the cornucopia, wears the crowns of the North and South, with a crescent in front, and is flanked by a seated

83. Harpokrates. Gold, Graeco-Roman.
*Boston, Museum of Fine Arts. John Michael
Rodocanachi Fund. 1971.140.*

dog and a similar eagle. A snake, partly freestanding, is coiled around the figure's middle; the ensemble is set on a small, rectangular plinth. H. 0.019 m. Boston, Museum of Fine Arts, 1971.140. John Michael Rodocanachi Fund. Compare another British Museum example, with large wings and found in digging the foundations of the new London Bridge; Walters, British Museum *Silver Plate,* pp. 12f., no. 49, pl. V; C. Vermeule, *Polykleitos,* Boston 1969, p. 47, note 11: encircled by a delicately wrought gold chain.

## 84

**Three statuettes of Harpokrates** in Baltimore. There are a number of similar statuettes: the Walters Art Gallery [in Baltimore] has two unpublished figurines of Harpokrates of Graeco-Roman type in gold (57.1434) H. 0.032 m. and in silver (57.1435) H. 0.024 m. Another (57.1436) H. 0.54 m. came from the Warneck Sale (p. 34, no. 232) and has been described as a "Harpocrate panthé"; it is in silver. (Information kindly supplied by letter by Miss Dorothy K. Hill.) The gold example shows all the attributes well, including an animal's skin (?) around the body. The second silver statuette places a dog and a Horus falcon on the plinth, the latter in front of a stem entwined by the serpent. This figure is closest to fourth century B.C. models. The other silver image or "amulet," if the traditional Egyptian terminology is used, is a crude little affair, a "Harpocrates as Eros."

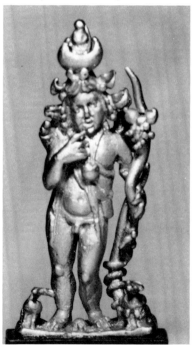

84. Harpokrates. Gold, Graeco-Roman.
*Baltimore, Walters Art Gallery.*

Roman Imperial

**85**

**Two statuettes of the seated Harpo-
krates.** The Metropolitan Museum of
Art in New York exhibits, in the
"treasure room" of the Department
of Egyptian Art, a pair of solid gold
statuettes of the seated baby Harpo-
krates, right hand at his lips and a
cornucopia on the left arm. H. 0.33
m. Although he wears the *uraeus* on
his head, the type is thoroughly
Hellenistic, based on the Ploutos of
the Eirene-Ploutos group identified
with Kephisodotos about 375 B.C.:
see G. M. A. Richter, *The Sculpture
and Sculptors of the Greeks,* New
Haven, Conn., 1950, pp. 257–258,
fig. 659. Andrew Oliver, Jr., reports
that the statuettes were probably
found together, but that each came to
the museum from a separate source.
One (10.130.1531) once formed part
of the Murch collection and was the
gift of Miss Helen Miller Gould in
1910: *Bulletin of the Metropolitan
Museum of Art,* 6 (1911), supplement
on the Murch collection, 27, fig. 21.
The other (44.4.31) was purchased in
1944 from the estate of J. Pierpont
Morgan, who had acquired it from
Maurice Nahman in Cairo.

**86**

**Gold Harpokrates-Horus.** The nar-
row line between amulet or pendant
and plain statuette in Hellenistic and
Roman Egypt is represented by a gold
Harpokrates-Horus, "hollow and
embossed in relief, standing with his
body and head inclined to the [his]
right and the left leg flexed, his right
hand held to his mouth and his left

arm around a tree trunk upon which
perches the figure of an eagle, on
raised rectangular base decorated
with bands of dots and looped hooks,
with suspension hook to the rear."
H. 0.038 m. Christie's Sale, 14 July
1971, p. 59, Lot 229, a, illustrated.
Dated circa second to third century
A.D. Compare also *Collection de
M. Guilhou,* Paris, Hôtel Drouot,
16–18 March 1905, p. 22, no. 125,
pl. VI: "pantheistic Harpokrates";
no. 124: canonical Harpokrates; both
are in gold.

**87**

**Gold draped Jupiter,** "a gold figure of
Jupiter, similarly worked, standing
with the lower part of his body
draped, his left hand on his hip, his
right raised to his head, with thick
beard and long hair, with two sus-
pension rings to the back." H. 0.031
m. Dated circa second to third cen-
tury A.D. Christie's Sale, as previous,
Lot 229b, illustrated. Zeus appears
to be hurling a thunderbolt, and the
figure is a frozen version of the Zeus
battling the giants in the center of
the east frieze of the Altar of Zeus at
Pergamon. Part of the stiffness of the
little image is inherent in its use as a
pendant that can also stand on its
own two "feet," or base. See also
p. 58, Lot 228, a–c, illustrated, gold
figurines identified as Jupiter, Isis-
Demeter, and a soldier in armor
(an emperor?) standing with spear,
shield, and helmet. This lot appears
to have been found with or to have
existed for a long time with the
previous; and the various pendant-

figurines in Lots 230, 231, p. 60: Isis,
"a goddess, probably Ceres, standing
and holding a cornucopia, with two
suspension rings on the plain back."
(H. 0.018 m.).

**88**

**Gold Nike-Victoria,** on a high pedes-
tal; said to be the top of a standard,
by S. Reinach, but identified by
G. M. A. Richter as a solid gold
pinhead of the first century A.D.
H. 0.048 m. New York, the Metro-
politan Museum of Art. Reinach,
*Rép. stat.,* V, 1, p. 203, no. 5; cites
G. M. A. Richter, "Classical Acces-
sions, II. Jewelry." *Bulletin of the
Metropolitan Museum of Art, New
York,* 16 (1921) 59f., fig. 3. She ap-
pears to be a Nike-Athena, holding a
spear in her right hand and a shield
on the left arm. The workmanship
seems somewhat crude, although the
influence of a large (architectural)
statue, like that at Ostia, can be seen.
The prototype goes back though to
the Hellenistic period and seems to
have been favored for works on a
small scale in various media.

**89**

**Nike-Victoria in silver.** H. 0.027 m.
Baltimore, Walters Art Gallery,
no. 57.1481, which is presumably
*Succession de Mme E. Warneck,*
Paris, Hôtel Drouot, 3–4 May 1905,
p. 33, no. 229. This entry in the sale
catalogue also included: "Vénus
accoudée sur une colonne, couronne-
ment d'épingle de cheveux" (not,
obviously, to be compared with the
large statuettes, discussed above).

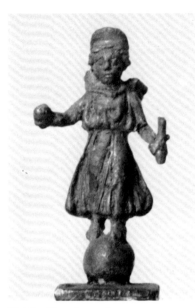

89. Nike. Silver, Graeco-Roman.
*Baltimore, Walters Art Gallery.*

The Baltimore Nike stands on an orb and holds a wreath (?) in her raised right hand, a palm branch in the left; she is diademed. The date is rather late, and the work is somewhat provincial.

## 90

**Nike-Victoria in gilded silver.** "Debout sur un globe, les ailes éployées, tenant des deux mains des gerbes d'épis." H. 0.035 m. *Succession de Mme E. Warneck,* Paris, Hôtel Drouot, 3–4 May 1905, p. 33, no. 228.

## 91

**Satyr in silver.** He is standing, with a bunch of grapes in the right hand.

H. 0.09 m. *Succession de Mme E. Warneck,* Paris, Hôtel Drouot, 3–4 May 1905, p. 33, no. 227 bis.

## 92

**Gold statuette of a grotesque figure,** a slave or a street person in a long garment, an ape-like figure from the Hellenistic theater. He is balding and wrinkled, with grimacing features. The provenance is given as "Dalmatia." M. Abramić and A. Colnago, *Jahreshefte des oesterreichischen archäologischen Instituts, Beiblatt* 1909, col. 111 (fig. 84, where the caption reads "Messergriff aus Bein"); Reinach, *Rép. stat.*, IV, p. 357, no. 3. as gold. The subject is rare, if not unbelievable, in the precious metals. The tradition could be Alexandrian, from pre-Macedonian Egypt (a statuette of an Isis priest?). The pepper "castors" or shakers, discussed earlier, prove the tendency to follow Hellenistic genre taste in the precious metals, but "slum subjects" or those from the theater are less frequently encountered in gold and silver.

## 93

**Graeco-Roman eagle** seated on a goat's head, between the horns. Silver, solid cast and chased. H. 0.037 m. Once in the Nelidow collection; acquired in Constantinople. L. Pollak, *Klassisch-Antike Goldschmiedearbeiten im Besitze Sr. Excellenz A. J. von Nelidow,* Leipzig, 1903, p. 194, no. 552, pl. XX. The bottom of the animal's head is flat, so that the piece can rest on a surface such as a table. Pollak cited a similar

bronze; Reinach, *Rép. stat,* II, p. 771, no. 7, and a number of such pieces of all sizes have appeared on the art market from Anatolia in recent years, especially since 1960. This, therefore, is an example of an unusual type of Graeco-Roman votive bronze from Anatolia fashioned in silver.

## 94

**A goddess of the Roman imperial world,** third or fourth century A.D. Silver with gold inlay and a garnet amid the goldwork in the center of her diadem. H. 0.21 m. Museum of Fine Arts, Boston, 66.425. Theodora Wilbour Fund in memory of Charlotte Beebe Wilbour. *Centennial Acquisitions, BMFA* 68 (1970) 28, no. 12. C. Vermeule, *The Burlington Magazine* 113 (July 1971) 404, figs. 57-59. This splendidly baroque statuette is characterized not only by the wind-blown veil and the rich diadem but by the three golden snakes within the gold-bordered bodice of the chiton. With attributes of scepter-staff and phiale, this may have been the Celtic divinity Juno Sospita, worshipped widely in the Latin West.

## 95

**Upper half of a silver Aphrodite** of the Capitoline type, fourth century A.D. H. 0.146 m. The Minneapolis Institute of Arts, 69.84. The William Hood Dunwoody Fund. Sheila McNally, "A Small Silver Aphrodite," *The Minneapolis Institute of Arts Bulletin* 58 (1969), 16–18. Although the head seems large in proportion to the body and the eyes stare upward

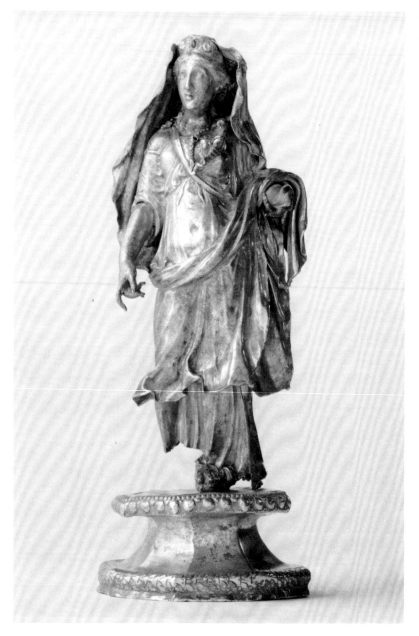

94. Goddess. Silver, gold inlay, garnet. Ca. A.D. 300. *Boston, Museum of Fine Arts. Theodora Wilbour Fund in Memory of Charlotte Beebe Wilbour. 66.425.*

as befits a Late Antique sculpture, this is a very powerful, albeit fragmentary work of art. It is everything that Aphrodite in the precious metals should be at a date not far removed from the end of the pagan world.

**96**
**Silver Venus** of the first half of the fourth century A.D. H. 0.197 m. Augst, Roman Museum. Inv. no. 62.59. From Kaiseraugst on the Rhine above Basel in Switzerland. R. Laur-Belart, *Der Spätrömische Silberschatz von Kaiseraugst,* 1933, p. 33, fig. 22; R. Heiger, *Jahrb. der Schweiz Ges. für Urgeschichte* 51 (1964), 113 (A). Her hair is gilded. She is nude, holds a mirror in her raised right hand, and pulls her tresses sideways and upward with her left hand. The somewhat unusually proportioned figure stands on a massive, circular, molded plinth or socle, which might have been made originally for a larger statuette. Coins, medallions, and silver bars date the other works of art in the treasure no later than A.D. 350, certainly not after 360.

**97**
**Silver statuette of a seated dancer,** inlaid with gold, about A.D. 350 to 400. A girl is putting on her right slipper. She sits on a spool-shaped hassock that is set on a raised, rectangular base. A number of secondary details have been carried out in gold. H. 0.12 m. Boston, Museum of Fine Arts, 69.72. Frederick Brown Fund. C. Vermeule, *The Burlington Maga-*

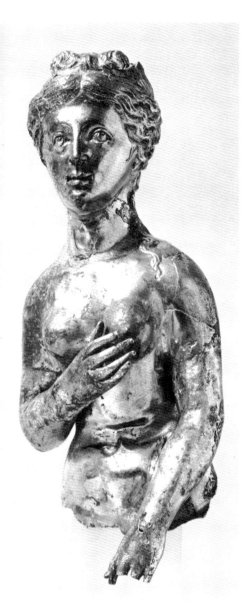

95. Aphrodite, Capitoline type. Silver, ca. A.D. 350. *The Minneapolis Institute of Arts.*

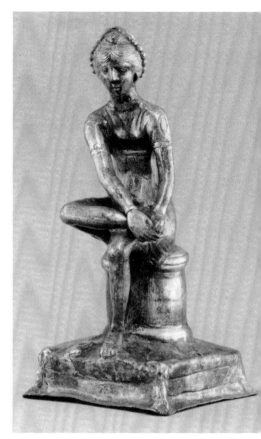

97. Seated dancer. Silver and gold, ca. A.D. 350-400. *Boston, Museum of Fine Arts. Frederick Brown Fund. 69.72.*

*zine* 113 (July 1971), 404, figs. 55f. There are a number of parallels for the hair style of the girl in the portraits of empresses on coins, from Helena the mother of Constantine the Great around A.D. 325 to Eufemia, A.D. 467 to 472, daughter of Marcianus and wife of Anthemius in

33

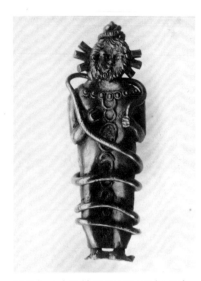

98. Solar god. Gold, Roman Imperial period. *Geneva, Musée d'Art et d'Histoire.*

99. Bull. Silver, Roman Imperial period. *Geneva, Musée d'Art et d'Histoire.*

the West. A number of the best relationships, including those with statuary and relief, belong in the period of Theodosius I (A.D. 379–395).

**98**

**Solar god in gold.** Roman imperial period. H. 0.05 m. Geneva, Musée d'Art et d'Histoire, no. Q18. From Leontini (Lentini near Syracuse) on Sicily. W. Deonna, "De quelques monuments connus et inédits, Dieu solaire du Musée de Genève," *RA* 1912, pp. 354–372, figs. 2–5. The god's hairy, bearded face is very barbaric in style. He has six heavy rays behind his head, wears a tight garment with a collar of seven circles ("mince rondelle d'or avec une perle"), and a series of six chains or joining circles down the front, and holds a snake-like object in his left hand. This runs behind his neck and around his body from waist to ankles. Christiane Dumant has written "peut-être prophylactique ou amulette," and the association could be with a cult such as that of Mithras. Deonna's nearest visual parallel (p. 358, fig. 4, no. 3), is with the Mithraic Kronos, but there are important differences in iconographic detail. In fig. 5 on p. 364 he diagrams the rays, circles, and "chains" as various planets, with the sun as the god's face and again as the center circle. The statuette is further evidence of the large number of exotic or unusual divinities represented by statuettes in gold and silver.

**99**

**Silver statuette of a standing, pawing bull.** Roman imperial period. H. 0.08 m. L. 0.092 m. Geneva, Musée d'Art et d'Histoire, no. 18725. From the Vallee du Rhône (France). Mentioned in *Genava* 27 (1949) 4. (Information and photograph kindness of the Curator, Christiane Dunant). Statuettes of this conventional type and generalized nature are difficult to date. From the stylized hair, eyes, and folds from the neck, this bull could have been cast as late as the reign of Julian the Apostate (A.D. 361 to 363), when there was a pagan revival of Graeco-Egyptian cults and the Apis-bull was placed on Roman imperial bronze coinage. The Apis-bull is identified by the sun-disc attached to the head between the horns, and bronze bulls of this type often contain holes for fixing such a disc. An example from the Athenian Agora was cast in lead: see M. Comstock, C. Vermeule, *Greek, Etruscan, and Roman Bronzes in the Museum of Fine Arts, Boston,* Boston, 1971, p. 143, no. 169 and references. These statuettes, like the coins of Julian, are found as often, if not more often, in the Latin West as in the Greek East.

**100**

**Silver standing bull,** Roman imperial period. H. 0.48 m. L. 0.55 m. Boston, Museum of Fine Arts, 1973.215. Theodora Wilbour Fund in Memory of Charlotte Beebe Wilbour. From an old British private collection and presumably from Roman Britain.

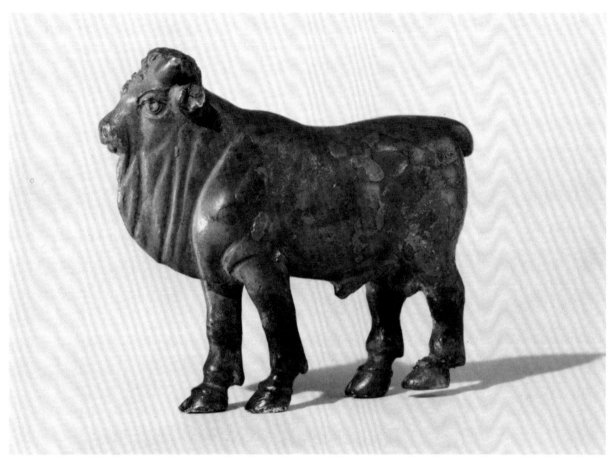

100. Bull. Silver, Roman Imperial period.
*Boston, Museum of Fine Arts. Theodora*
*Wilbour Fund in memory of Charlotte Beebe*
*Wilbour. 1973.215.*

This small figure is of canonical type and excellent workmanship, especially the forelocks and the dewlaps. A tiny hole in the forehead, between the horns, may have been for the solar disc of an Apis-bull or for the third horn of a Celtic bull (Marion True). Compare the standing bull from Rhodes and the walking bull from Savona in the Museum of Fine Arts, both having been fashioned in bronze: M. Comstock, C. Vermeule, *Greek, Etruscan, and Roman Bronzes,* pp. 142–144, nos. 168, 169, and further citations. This silver bull is of a patently pan-Mediterranean type, much less "provincial" or "Gallo-Roman" than the example from the Rhône valley in Geneva.

## 101

**Gilded silver statuette of a togate Julio-Claudian prince,** perhaps one of the grandsons of Augustus or perhaps Britannicus, son of Claudius, or even Nero, represented as a *Genius Augusti.* H. 0.06 m. Cracow, National Museum, from the Czartoryski Collections. Found in Syria. K. Ciuraszkiewicz-Moczulska, in *Mélanges offerts à Kazimierz Michałowski,* Warsaw, 1966, pp. 321–323, figs. 1, 2. The young prince holds a *rotulus* in the left hand, a patera in the extended right. The statuette resembles a number of similar cult-figures in bronze: M. Comstock, C. Vermeule, *Greek, Etruscan, and Roman Bronzes,* pp. 150–151, under no. 174A. The gilded silver image gives evidence of having been cast for a mass market, like some of the silver bars collected

in the United States in the 1970's.

## 102

**Gold cuirassed bust of the Emperor Marcus Aurelius** (A.D. 161–180). H. 0.33 m. Lausanne, Kantonalbank. Found on 19 April 1939 "beim Ausräumen der römischen Kloake vor dem grossen Tempel des Cogoniers zu Avenches." *Illustrated London News* 194 (1939), 782, with illustration; P. Schatzmann, *Zeitschrift für Schweitzer Archäologie und Kunstgeschichte* 2 (1940), 69; M. Wegner, *Die Herrscherbildnisse in antoninischer Zeit,* Berlin, 1939, p. 169, pl. 27. A. Vavritsas, *Athens Annals of Archaeology* 1, 2 (1968), 195–197, fig. 3; *Enciclopedia dell'arte antica,* I, p. 936, fig. 1171. The "urbild" is of the type known as Museo Capitolino, Imperatori 38. The style of this head in gold is almost proto-Romanesque; the cuirassed bust is more "routine," less carefully detailed than that of the Lucius Verus from Marengo (see the following).

## 103

**Silver cuirassed bust of Lucius Verus** (A.D. 161 to 169), perhaps a posthumous, dynastic portrait. H. (max.) 0.553 m. Turin, (R.) Museo di Antichità. From the Marengo Treasure. Wegner, *Herrscherbildnisse,* pp. 11, 248, etc., pl. 41; G. Bendinelli, *Il Tesoro di argentaria di Marengo,* Turin, 1937, IIf., pls. 2f., figs. 5f. As a work of imperial portraiture, this Lucius Verus is more accomplished, more "Roman" than the somewhat "barbarian" Marcus Aurelius from

Avenches. The cuirassed bust gives the whole work of art the feeling of being a rough and ready version of a standard portrait, made in a military settlement after good models for the head, if not for the bust.

## 104

**Silver head and fragmentary, draped bust of an empress, probably Faustina II** (died A.D. 175) or Lucilla (wife and widow of Lucius Verus) as Aphrodite or possibly Nike. H. 0.10 m. Turin, Museo di Antichità. From the Marengo Treasure. *Ori e argenti dell' Italia antica,* Turin, 1961, p. 206, no. 702, pl. LXXXIII. Although stiff, frontal, and idealized, this is clearly a portrait similar to the Lucius Verus. There is a good parallel in marble, in the head of Faustina II or Lucilla as Aphrodite, with a similar topknot, from the Hadrianic baths at Aphrodisias in Caria and now in Copenhagen, Ny Carlsberg Glyptotek: K. T. Erim, *AJA* 71 (1967), 237, pl. 68, figs. 12, 13. Either Faustina II, wife of Marcus Aurelius, or their daughter Lucilla could be found in such a treasure of Antonine dynastic images. This head can be compared with profit to the Late Antique Capitoline Aphrodite, also in silver and not a portrait, in the Minneapolis Institute of Arts (see above). With the Lucius Verus and this fragmentary empress were found a number of other, some-fragmentary sculptures in silver, arm of a Victoria, the Signs of the Zodiac, or an eagle, appropriate to the later Roman, imperial cults; see *Ori e argenti dell' Italia antica,*

pp. 205–210, nos. 699 (the Lucius Verus) to 720 (plaque to Fortuna from the Senator M. Vindius Verianus, Admiral of the Black Sea Fleet).

## 105

**Silver cuirassed statuette of a Roman emperor,** cloak over the left shoulder and around the left arm. His raised right hand held a spear or staff; a short sword or *parazonium* was in the lowered and extended left hand. H. 0.025 m. Boston, Museum of Fine Arts, 1971.141. John Michael Rodocanachi Fund. The features are difficult to identify precisely, whether Septimius Severus, about A.D. 200, or Marcus Aurelius, at the time of his death in A.D. 180.

105. Cuirassed emperor, Marcus Aurelius or Septimius Severus. Silver, A.D. 180 or 200. *Boston, Museum of Fine Arts. John Michael Rodocanachi Fund. 1971.141.*

The cuirass type with the profusion of smallish, semicircular *pteryges* would appear to be Severan, the revival of Flavian forms: see *Berytus* 13 (1959) no. 297, pl. 22, fig. 67, Caracalla (?) as a youth, in the Villa Torlonia-Albani in Rome. The plain cuirass is perfectly correct for the Severan period, as the statue of Septimius Severus from Alexandria demonstrates: no. 292, pl. 21, fig. 66. If Marcus Aurelius, this statuette could be a posthumous votive image produced in the Severan era. My instinct is to favor Marcus Aurelius for the subject; compare the Marcus Aurelius that is Rome, Museo Capitolino, Imperatori 38; Wegner, *Herrscherbildnisse,* pl. 26, mentioned as the ultimate prototype for the gold bust from Avenches (see above).

## 106

**Cuirassed gold bust of Marcus Aurelius** or, more likely, Septimius Severus. Komotini Museum (?), from Didymoteichon in Thrace (seemingly ancient Plotinopolis). The height has been given as about 0.25 m. A. M. McCann, *The Portraits of Septimius Severus, Memoirs of the American Academy in Rome* 30 (1968), 143, no. 29, pl. XL, compared with portraits of Severus, Type VII; G. Daux, *BCH* 89 (1965) 683; C. Vermeule, *Roman Imperial Art in Greece and Asia Minor,* Cambridge (Mass.), 1968, pp. 425, 515: Marcus Aurelius; A. Vavritsas, "Gold Bust from Didymoteichon," *AAA* 1, 2 (1968), 194–197 and color plate. The color photos, views from five angles, sug-

107. Imperial Genius of the Second Tetrarchy. Silver, ca. A.D. 316. *Baltimore, Walters Art Gallery.*

gest Septimius Severus in a form designed to recall Marcus Aurelius, his dynastic "father." The conclusion seemingly must lie in the iconographic identification of Professor McCann, although Mr. Vavritsas uses the Capitoline marble and equestrian Marcus Aurelius for comparison. He also writes (p. 197): "Such busts, smaller than life size were used by Roman legions, either carried on the standard, labarum (vexillum), or borne by the Image-bearers (Imaginiferi)." He adduces (fig. 4) the tombstone of Genialis at Mainz, the

soldier being the image-bearer with his handy, portable icon in his right hand.

## 107

**Statuette, in silver, of the genius of an emperor of the second tetrarchy.** Baltimore, Walters Art Gallery, 57.1819. H. G. Niemeyer, *Studien zur Statuarischen Darstellung der Römischen Kaiser, Monumenta artis romanae* VII, Berlin, 1968, p. 91, no. 35, pl. 11, nos. 1 (this) and 2 (replica in the Louvre). First related to the silver litter-pole statuettes of the Esquiline Treasure and dated by Marvin C. Ross at the end of the fourth century A.D. (in *Studies Presented to David M. Robinson,* I, Saint Louis, 1951, pp. 794f., pl. 100), this statuette has been dated iconographically by H. G. Niemeyer at the *beginning* of the century, in the "Genius cult" of Constantine the Great, perhaps on his Decennalia about 316. The cult of the Genius presumably *stopped* under Theodosius in A.D. 392.

## 108

**Gold statuette of a man, from Gaul,** late fourth to early fifth century A.D. Cast with engraving, and a stamped decoration. H. 0.118 m. Washington, D.C., Dumbarton Oaks, Trustees for Harvard University, 36.46. Bliss Collection. Said to have been found in 1928 or a little earlier in the region of LeMans, France, near the old Roman road from LeMans to Tours. E. Kitzinger, et al., *Handbook of the Byzantine Collection, Dumbarton Oaks,* Washington, D.C., 1967, pp.

67f., no. 244, plate. M. C. Ross, *Catalogue of the Byzantine and Early Mediaeval Antiquities in the Dumbarton Oaks Collection,* II, *Jewelry, Enamels, and Art of the Migration Period,* Washington, D.C., 1965, pp. 126–128, no. 174, pls. LXXXVII–VIII, color plate F. The handbook sums up: "An unusual statuette, cast in solid gold, showing a man with a very long chin standing rigidly in a frontal position, his arms clasped at his sides. He wears a tunic decorated with a punched design. The modelling of the body is minimal and the features of the face crudely worked. The statuette, which may be a votive figure, has been dated as late as the seventh to eighth century, but is now thought to have been made in Gaul in the late fourth or fifth century." In either case this figure carries the history of statuary in the precious metals into the early Middle Ages in the Latin West. It terminates a long and productive history.

# Creations in the Manner of the Antique: Modern Forgeries and Post-Renaissance Works

## 109

**Athena "Promachos" in gold,** of Etruscan or Italic type, and seemingly of the late Archaic period. H. 0.09 m. Paris, art market, in 1962. The "smile" recalls Dossena's pseudo-Archaic sculptures, and the "woolly" patina is of a type not regularly associated with ancient gold. In short, this is a modern forgery, probably produced in Rome about 1960; other works by the same hand have been seen over the past decade, usually Etruscan gold pins or plaques. Compare, in bronze, M. Santangelo, *Musei e Monumenti Etruschi,* Novara, 1960, p. 133, five bronzes; also G. Q. Giglioli, *L'Arte etrusca,* Milan 1935, pl. CXXV, no. 3, Florence, Museo Archeologico, from Fermo (Marche). For the style, compare pl. CCXXII of Giglioli, showing spindly warriors from Italic sites.

## 110

**Statuette, in silver, of a nude warrior** with an elaborate, crested helmet, "Ajax." He is plunging a short sword into his chest just over the heart. H. 0.12 m. Yale Art Gallery, 1961.31. From the London market (?). Auktion Helbing, Frankfurt, 5 December 1929, *Antike Kleinkunst der Sammlung R. von Passavant – Gontard,* Lot 44, p. 21, pl. X, "wherein it is said to have been bought in Lyon in 1868" (reference in a letter from Andrew Oliver, Jr., 15 January 1971). The catalogue states: "Römisch, nach einem griechischen Vorbild vom Ende des 4. Jahrh." The subject, iconographically, appears to be a cross between the Gaul of the Pergamene group of the Gaul Slaying his Wife and the Menelaos, with similar helmet, of the group of Menelaos with the body of Patroklos. The latter seems all the more related when we recall that in the Renaissance to modern times the Menelaos-Patroklos groups were termed "Ajax with the body of Achilles." For an ancient, three-dimensional "Suicide of Ajax," compare the classical Etruscan bronze from Populonia in the Museo Archeologico at Florence: Giglioli, *L'Arte etrusca,* pl. CCXVII, nos. 1, 2. The Yale statuette, in short, must be a sixteenth or seventeenth century creation in the antique style.

## 111

**Solid gold bull,** in the pose of the famous marble sepulchral animal in the Kerameikos, Athens, or of the beasts on the coins of Thurium in the fifth and fourth centuries B.C. Naples, Museo Nazionale, no. 24852. Gift of Marchese Enrico Forcella. L. Breglia, *Catalogo delle oreficerie del Museo Nazionale di Napoli,* Rome 1941, p. 100, pl. XLV, no. 2. The bull is set on an oval base, also in gold, with an inscription in Archaic Greek script which has been shown to have been copied from another, genuine, from Motya. The style mixes the Greek fifth century B.C. with Graeco-Roman or even Late Antique bulls. Without the base, it could be an eclectic product of the Roman imperial period, but the ensemble emerges as a "literary" creation, probably of the nineteenth century.

# Epilogue

Nearly all points to be derived from a catalogue of Greek and Roman statuettes in gold and silver have been summarized in the introductions. It is obvious that much of the best ancient craftsmanship in the precious metals went into jewelry to be worn or utensils and vessels to be displayed on ceremonial occasions. The borderline between sculpture for sculpture's sake and jewelry or utensil has been crossed on one or two occasions in this catalogue. It is difficult to tell whether a small golden Nike was a votive image or the culminating element of a large pin. There are also statuettes, like the Pergamene baroque silver centaur from a rhyton in Vienna (D. E. Strong, *Greek and Roman Gold and Silver Plate,* London, 1966, p. 109, pl. 27B), which can be understood as integral works of art regardless of their original function.

The catalogue presented in these pages can easily be enlarged, but it does not seem that an exhaustive list or a grand series of new discoveries from the earth will alter the picture of Greek and Roman statuary in gold and silver. In all senses, quantity, quality, and scale, the subject can be classed as a meager one, but, by the same token, our knowledge of the great masters of Greek sculpture in many decades of classical civilization from Myron into Roman imperial times is hardly more complete, without literary references and Graeco-Roman copies in marble. What survives in statuary of gold and silver from the fifth century B.C. through the fifth century A.D., a span of ten centuries, is a small but informative (and heretofore not fully documented) chapter in the most materially oriented art of antiquity.

# Index of Locations

# Index of Subjects